Home Photogra

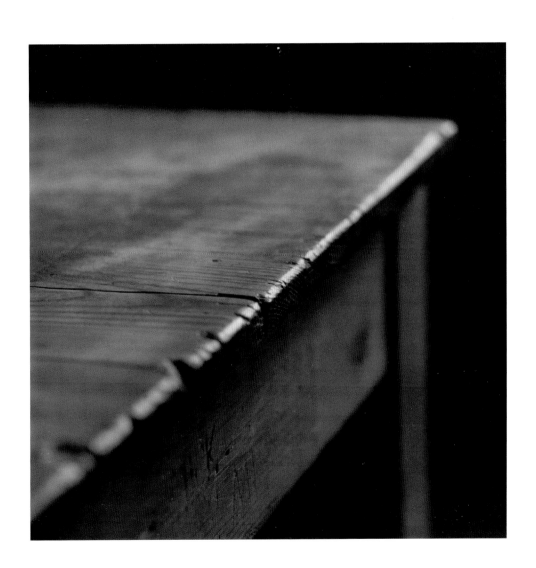

Andrew Sanderson

Home Photography

Inspiration on your doorstep

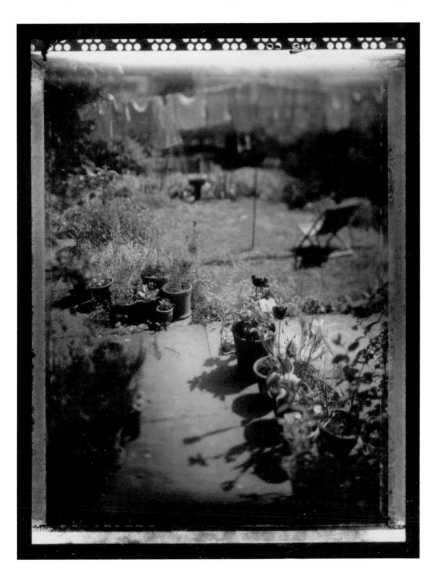

Andrew Sanderson

Argentum

First published 2003 by Argentum
an imprint of Aurum Press Limited,
25 Bedford Avenue, London WC1B 3AT

A catalogue record for this book is available
from the British Library.

ISBN 1 902538 29 3

Design: Eddie Ephraums
Layout assistant: Louise Ang

Printed in Hong Kong

10 9 8 7 6 5 4 3 2 1
2007 2006 2005 2004 2003

Title page: The view from my back door.
I had recently acquired an old monorail 5x4 camera and was trying out the various movements. As I looked at the image on the ground glass, I was struck by how magical the areas of soft focus were, so I took a shot on Polaroid type 55 Pos/Neg film and tinted the final print with a solution of dye.

Acknowledgements

I would like to thank my wife, my children and my parents for their support, time and understanding throughout the writing of this book.

My grateful appreciation goes also to Dave Hill for his ability to spot my mistakes, and to David Stirrup, who, as my unofficial proofreader, spotted even more. Plus, Ian James at ILFORD UK for material support.

Also a big thank you to Sue Stockwell who gave freely of her time when I had a difficult commission to undertake during the busy last days of working on this text.

Contents

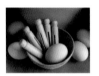
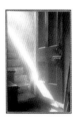
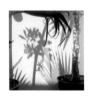

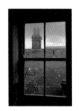

LOOKING CLOSER
Keeping it all in mind
Page 66

FOUND OBJECTS
Keeping to your vision
Page 72

PEOPLE
Visitors
Self portraits
Children
Page 78

PETS
What am I doing wrong?
When things don't go as planned
Page 88

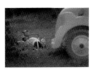

TOYS
Being honest with yourself
Page 96

MAKING PICTURES HAPPEN
What should you take pictures of?
Page 102

A SHORT WALK
Demistifying photography
Page 106

EXERCISING YOUR VISION
Seeing with peripheral vision
Being visual
What should I be looking at?
Composition
Choosing lenses
Can you manage with your equipment?
The right equipment
Technical information
Page 112

THUMBNAILS
Page 126

Introduction

Within these pages I wish to impart the message that great pictures are all around you, and that all you have to do is look.

Welcome to the home book, an antidote to those publications that imply that great pictures can only be taken with the most expensive equipment, and in the most exotic and far flung locations.

Within these pages I hope to impart the message that great pictures are all around you, and that all you have to do is look.

This book is not going to be about the techniques of photography. Technique in itself can be boring for many and I wanted to give you a more complete picture, to let you inside my head and to show you the thought processes and ideas that spawn the photographs. At times this is going to be difficult for me, as it is often harder to explain things than it is to demonstrate or do them

So please allow me to ramble on occasionally. I'll try to stay away from long winded explanations, but remember that doing the things I describe is often much simpler than the explanation itself, and it is certainly much more fun to do it than to read about it!

The pictures in this book have mainly been photographed in my house, and I realize that my taste is not everyone's, but whether you agree with my decor or not, please see this as a book of ideas, not as a gospel. I am not saying that you should take pictures like mine, only that you could learn to look closely at your own location for inspiration.

I hope these photographs will give you ideas and get you excited about taking pictures in your own home. If you find yourself trying to copy my pictures, I will be flattered, but the real purpose of this book is to make you see your place and your objects differently, to photograph things that I haven't seen yet. I want you to take another look at everyday things and to dispel those unwritten rules about what makes a possible subject and what is necessary before a picture can be taken, so that you can make photographs which are personal to you. I hope I can instil in you new ways of thinking about photography and along the way I will share my personal views and thoughts - deep stuff eh?

I have tried to keep the technical jargon to a minimum and what there is I have put towards the back of the book, because this is not a technique book as such. Instead, I have written about what inspires me, how I see and what I think makes a great picture. I have written things that I have never talked to other photographers about, never even discussed with my wife. Some are strongly held beliefs and some are nearer to a personal philosophy.

Have a look through the text - you are free to take inspiration from wherever you find it. That may be from different parts of the book, or it may be simply one sentence which makes you think that you can do it.

I was indecisive about including some of the more philosophical parts of the text at first, but decided to go with it in the end, because I wanted to give you the complete picture about all the elements that go into the 'when and why' of my photography, as those parts are just as important to me as taking an exposure reading.

I suspect a lot of photographers have thoughts like mine, but in this serious world that we live in, 'airy fairy' ideas are seen as a distraction, a childish diversion.

I would argue, though, that these ways of thinking are essential to a healthy, creative mind.

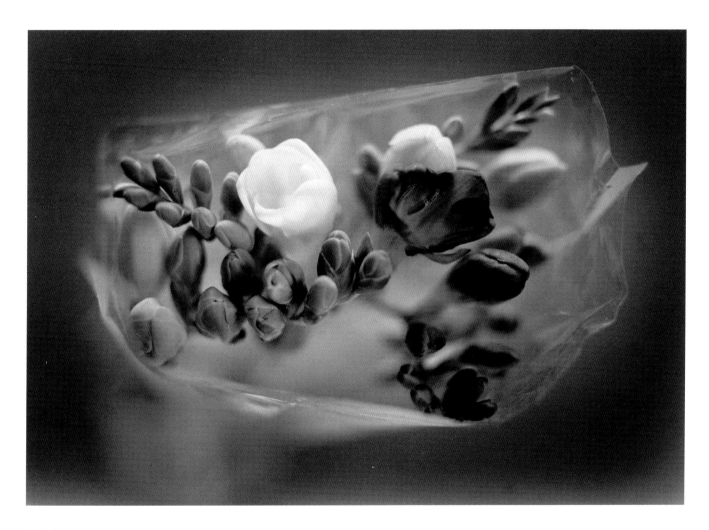

Freesias.

I first photographed these freesias from the side, but didn't feel that I had created anything special. I was about to put them away when I looked at them from above and saw this.

1 - Pictures everywhere

Wherever you are, there is a picture waiting to be discovered and recorded on film.

This is a philosophy that has permeated my photography for over twenty years: the idea that images sit around waiting for us to notice them. Not just in spectacular or far flung places, but closer to home, inside the home or about your person. Everywhere.

There is a picture in the room where you are now. It could be a wide angle view of the room, it could be a close up of an ornament or fingernail. You could photograph the view out of the window, cracks in the plaster or a microscopic part of the carpet. Any of these things could make an interesting picture if done properly. But how do you do it properly? How do you make ordinary things look powerful?

Everyone knows the old adage of: 'It's not what you've got, but what you do with it.' Well, I would like to present a slightly different version which is more appropriate for picture making: 'It's not what you photograph, but how you present it.' I'm sure we have all seen both good and bad pictures of all types of subjects, but have you ever asked yourself what makes the difference? If a number of photographers were given the same object to photograph, or sent to the same location, would they all return with exactly the same image? Obviously not. Some would succeed in putting across the image better than others. Some of those photographers would have given the picture a 'certain something' that managed somehow to distil the essence of the scene into a powerful two-dimensional visual message.

Is it fair to say that this would only have been achieved by those who were fortunate enough to own the best equipment? I believe not! A pinhole camera made from a biscuit tin, used by a photographer with vision, can produce far better images than an idiot operating a Sinar 10x8.

Choice of equipment is only part of the story. In any given photographic situation there are a multitude of possibilities. There are nine formats between half frame and 10x8", there are hundreds of photographic emulsions to record on, unlimited lighting possibilities, blur, focus shift, movement, colour, black and white, hand colouring, lith printing, gum printing, cyanotype, bromoil, platinum, salt printing, not to mention lens choice and angle of view. With all these choices and possibilities, is it not feasible that you might find some way to make the most ordinary of subjects look special?

So, if having the most expensive equipment is not necessarily the way to make the best pictures, what is? Well, you can have the finest equipment in the world but if you don't know where to point it, it is useless.

First of all you need the vision, and as I said before, and have said many times to my students, much of it is in the presentation, the method of printing, the style of print, the correct choice of paper and the appropriate print size. They are all small considerations, but each is important in its own small way. Get each element right, and the finished picture is far better for it. So look around you, practice using your vision and see those pictures which are right under your nose.

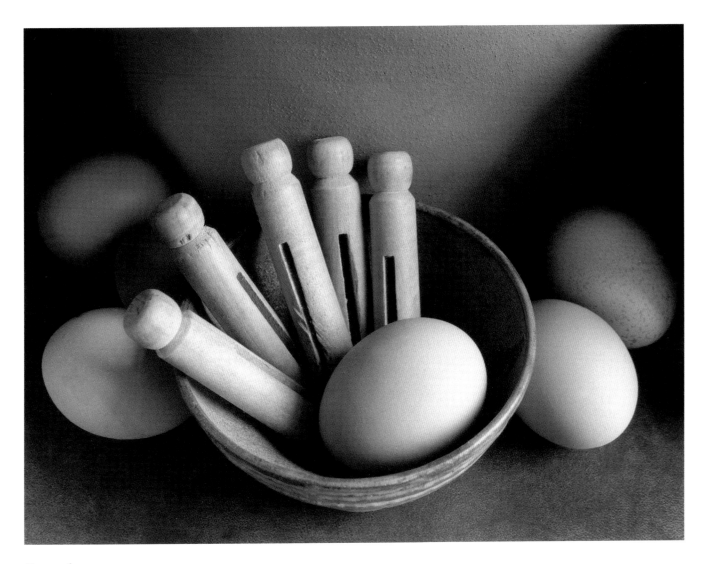

Eggs and pegs.
Taken to kill time when visiting my mother-in-law's house. My wife and
her mum were deep in conversation for most of the day and we had no
children at the time to keep us busy.

Developing a style

Developing a personal style is usually something that takes many years and tends to creep up on you.

You will notice people saying things like, 'That looks like one of yours', or less flattering, 'Oh, you've done another one of those.' The important thing to remember is to photograph whatever you like to look at, and then see if anyone else is on the same wavelength. Don't take pictures because you are trying to please someone else (I'm not talking to commercial photographers here), because you will invariably find that fewer people actually respond. Shooting from the heart produces pictures that 'sing' – pictures that affect people. It also generates varied and diverse types of work, whereas the other method creates stagnation.

For years I have had the mickey taken out of me mercilessly for getting excited about seeing pictures in ordinary or unexpected places. One instance sticks in my mind. I was walking through the town I live in one day, and I stopped dead in my tracks to exclaim: 'Look at the cracks in that paving stone, that would make a great picture!' I never lived that one down.

Being ridiculed hasn't stopped me though. I won't be put off photographing something by worrying what other people think. I believe that it is very important to be yourself, and not to photograph things simply because they are fashionable, or, worse still, avoid photographing things because of what others may think. Taking a picture when the inspiration takes you will often mean shooting whilst other people are watching. If being self-conscious about having other people around is going to cause you to avoid using the camera, then you will have to find a way around this, or miss many fine picture possibilities.

You may find people looking at you when you are shooting, but this is not something to worry about. Your pictures are much more important and should have priority. The photograph could last for hundreds of years (if processed archivally) but they will have completely forgotten about you soon after the event. You will never develop a personal style by avoiding the camera. Once your friends and family know that photography is what you are serious about, they will accept your behaviour as normal.

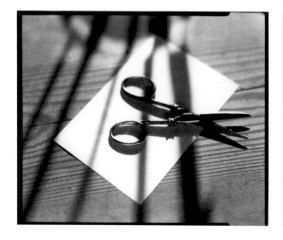
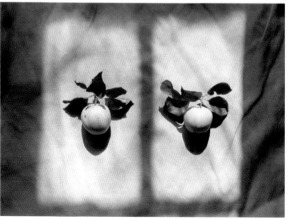

These two images show how the light coming into the room can make or break a shot. The shadows become an important element of the composition.

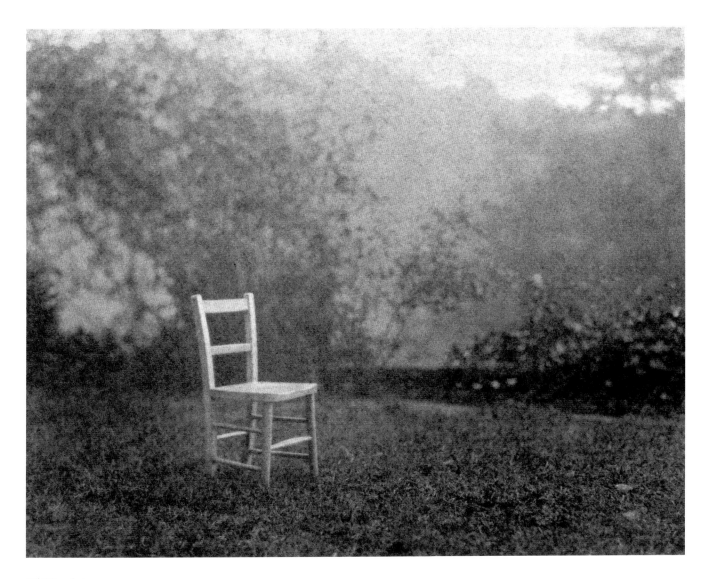

Child's chair.
At my old house, one of the windows looked out onto the next door
neighbour's lawn where a child's chair had been left. Taken from the
window using paper in the back of a 5x7" plate camera.

Getting feedback from others

It is natural to have a need to show your early work to friends or partners to get some feedback about your progress, and let's be honest, we all like to be complimented. Unfortunately, but not surprisingly, this is not going to happen with every person who looks at your work, regardless of how good you are, and I can speak from experience.

We are all different people, with very varied tastes and influences. Each person reacts to a picture differently. Some will notice things that you yourself have overlooked, and some will miss the obvious completely. Don't believe that they all have the correct opinion about your photography. Use the compliments to build up your confidence, and don't let the criticisms set you back. If the same points keep coming up with different people, then there may be something that needs addressing, otherwise negative comments should not be taken personally.

The reactions that I get from my pictures are many and varied, some good, some bad – some bizarre! It can be quite nerve wracking to have someone look through your portfolio, especially if that person is very visually aware. The pictures are so personal that comments can be felt rather more deeply than perhaps they are intended by the viewer.

A great photographer friend of mine by the name of David Guest used to say years ago that showing your work was like walking naked down the main street of your town, and at the time I didn't really understand what he meant, but as my work has become more personal I have been haunted by his words. The flip side of this discomfort is that when someone really likes a picture of mine, it gives me a great feeling. I feel I have met someone who sees as

I do. I can only describe it as like meeting someone for the first time and becoming very good friends. Now that I am presenting my work (and my thoughts) in a widely distributed book, I feel more like I am walking naked in front of a stadium full of people!

As you continue to refine your vision and improve your technique (a never ending quest), remember that your friends and partners may not have progressed as far visually or aesthetically. Their comments may seem offensive occasionally, but you must allow them their opinion.

Don't be swayed from your destination. You must continue to photograph the things that give you pleasure or motivate you, otherwise your photography is pointless. If other people have strong ideas about what you should be shooting, then tell them to get their own camera. If you need the opinions of others to give you the reassurance to continue, you will need to choose carefully who you ask. Members of your family may be overly critical, or, at the other extreme, wildly overenthusiastic about everything you do. Neither is helpful.

Even the 'experts' differ in their opinions of what makes a good photograph, so you may not get an objective view from another photographer. Older photographers may have very fixed ideas about what is allowed and what is not, according to their internal 'rule book', and those who are nearer to your own age group and working in a similar way may be motivated by jealousy. Asking the opinions of others can be a bit of a minefield and can often set you back. The only person who really knows if you have achieved your goals is yourself. Learn to trust that opinion.

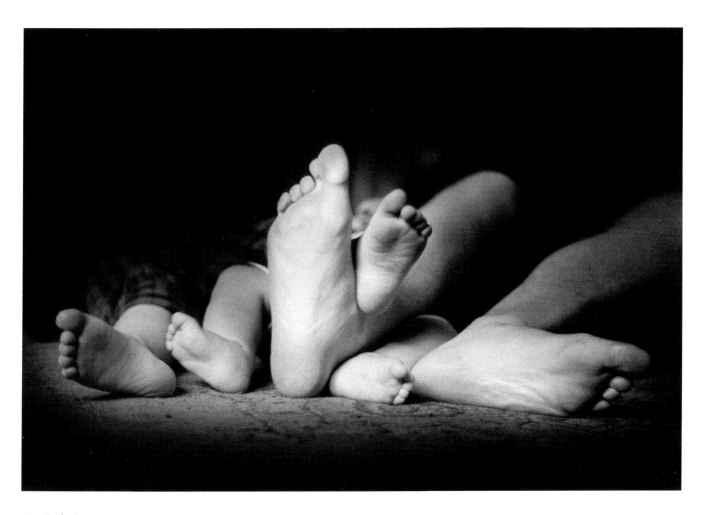

Family feet.
This picture was done just as a bit of fun, as a different sort of family group shot. The light was poor, so I had to shoot wide open on a 50mm 1.4 lens. This made the image a little soft, but allowed me to lose the background, making the feet more prominent.

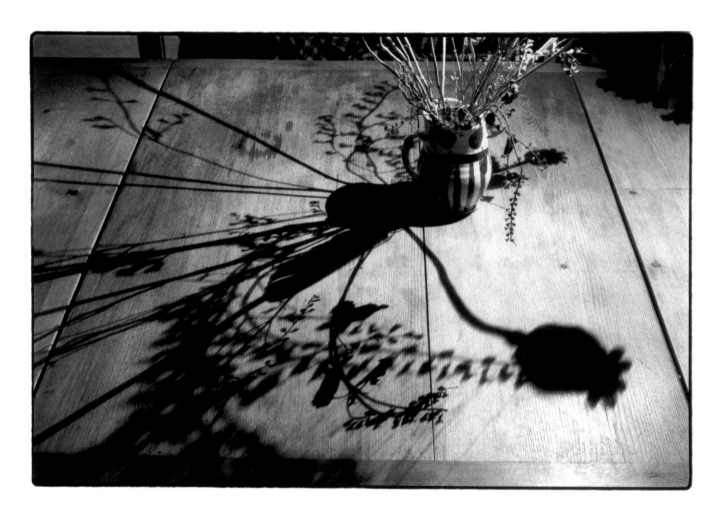

Shadows of dried flowers.
I had recently bought a bedside reading lamp which had a small halogen bulb inside a silver reflector. When I removed the reflector the light, being small, cast very sharp shadows. For this shot I held it over the vase and close to the seed heads to create large shadows.

2 – My *home is my studio*

I *have been abroad a number of times, but the place that* **I** *spend the most time is my home.*

Like many people, I have been abroad a number of times and travelled to various places within my own country. This often produces some interesting landscapes and architectural studies, even a few decent portraits, but the place that I spend the most time is my home.

Because my travel time is limited, I figured that if I wanted to keep my interest up and my enthusiasm alive - by continuing to create pictures that please me and get me buzzing about photography - then I had to look more closely at the picture possibilities in my own location. It occurred to me that if I could find great pictures in another country, then a visitor from that country could very well do the same in my town, by virtue of the fact that everything looked different to the person who was a stranger to that location. Therefore, all I had to do was to see my surroundings afresh to create great pictures! At first this was a little difficult, but then so is anything if you've never done it before.

I decided to persevere and to give myself the task of seeing four pictures everywhere I went. The more I thought about it, the more excited I got about the possibilities. I wanted to learn how to see as a visitor.

In fact, my quest gradually developed into a kind of Pavlovian response in which I had to take a picture whenever I held a camera or thought about photography in any way - something that was happening many times a day. Whenever I got the 'signal' I would look around with 'photo eyes', seeing everything as a monochrome print, mentally drawing boxes around things and exploring different compositional possibilities. The pictures, once decided upon, had to be taken immediately, which wasn't always convenient. I was often criticized by my wife for being antisocial when I had to take pictures in the middle of a dinner party or at some other 'inappropriate' time.

You may not wish to take it quite this far, but I do think that the four pictures task was very useful, and it may be worth trying for a while. If you wish to adopt it, then give it time to produce results. Don't expect it to give you the goods on the first day, keep it going for as long as you can. If you find that you have missed days, don't give yourself a hard time over it, just carry on as soon as you remember. Before you know it, you will have hundreds of negatives and many of those will be strong images. If you spend a lot of your time at home, your task could be to find ten pictures in each room of the house, or ten pictures of each person in the house. Devise your own task if you like; as long as it gets you looking around and taking pictures, then it will work.

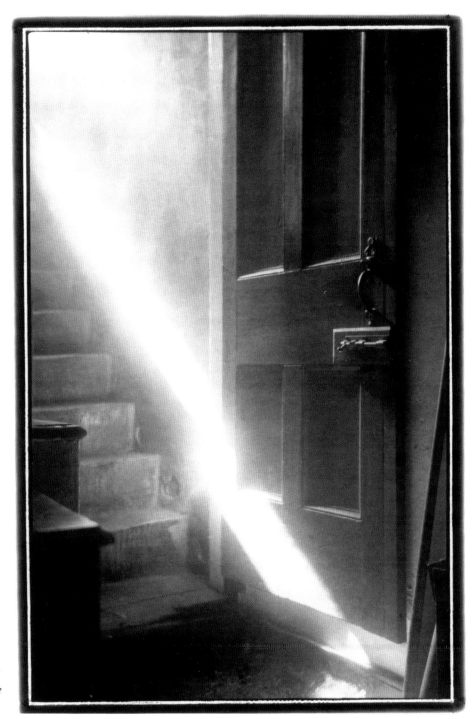

Light down cellar steps.
The strong diagonal of the light gives the scene more impact.

Getting a range of good pictures

As photographers you will no doubt already own some photographic equipment. Think back now to when you first acquired your camera – you were probably quite excited about it, and took pictures of many different subjects.

You were experimenting. You just photographed anything and everything, and you probably produced a number of interesting images. Technically, they would not have been as good as they could have been, but with practice they might have developed into different styles. Holding on to this early excitement is the best way to approach photography. It creates a wider range of images and a greater degree of fun. I still produce my best work when I am 'playing'. By that I mean playing with the camera, shooting whatever takes my fancy, with no pressure to conform to someone else's ideas. I also find that changing formats, or using a different technique for a while, keeps the excitement alive, and that can only create better images.

Experimentation is the key to creating fresh images for me, and if I only had room here to suggest one creative approach for you to have, it would be: do lots of experimenting. Experimenting with virtually any photographic technique will result in some kind of image. Doing lots of experimenting will result in lots of images, and some of those will be great pictures. At first, your ratio of great pictures to average pictures may be as low as one in a hundred, but with practice you will learn from your mistakes and achieve a higher hit rate. I have been telling my students for years that the only reason I have more good pictures than they do, is because I have made more mistakes!

All the pictures that you take are useful, some are worth looking at many times, and some are stepping stones to a greater understanding of your craft. Don't be discouraged if you haven't managed to create a masterpiece on each frame: you can often learn more from the mistakes than the shots that 'came out'. Having as many photographic techniques under your belt as possible will give you a wider palette and allow you to make choices about the subject in front of the lens. If you can maintain your excitement about photography, you will continue to create strong images. The longer you create, the greater the quality of work you will produce.

Every few years, you should look back and see how your work has progressed. If you get a little deflated by your early, more amateurish prints, then let me pass on a useful thought: as a friend recently pointed out to me, if you cringe at work you created a year or two ago, then you can take comfort in the fact that you have progressed! That should get your enthusiasm up again.

The sort of technique that you need to have to begin with, though, is mainly an understanding about exposure and lighting coupled with a good eye and an instinct for composition. Once you have these, you can widen your possibilities with knowledge of various films or processes. Some prefer to stick with one technique throughout their whole lives, but apart from the photographic limitations this way of working causes, the photographer is lost if their particular brand of film or paper is discontinued. Don't put all your eggs in one basket. 'Variety is the spice of life', as the saying goes.

One thing I must say is that an understanding of technique is very important, but don't be a slave to it – have an understanding of what is possible, and be open to the fact that sometimes fate or spirits will provide you with a better image if you can recognize the possibility as it arises. This is not to be confused with 'sod's law', which often begins the same way but ends with the opposite result.

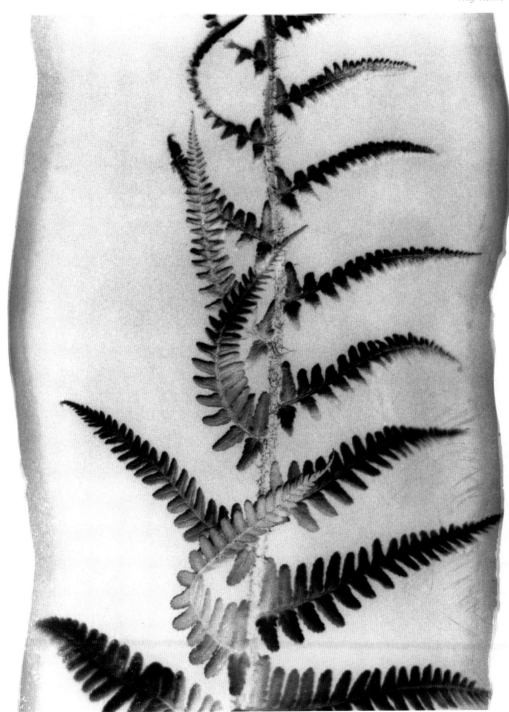

Fluid fern.
This is a
negative image
printed from a
Polaroid
instant B+W
35mm slide.

Putting mood into pictures

As a photographer I am emotionally affected by what I see. I can catch a glimpse of something and be completely transported to another place, either a long forgotten memory, a state of mind, or just a previously never before experienced mood or emotional state. The latter experience is always the most moving, but at the same time, the most difficult to describe. It is then that I feel that I perhaps experience some minor form of synesthesia. This is an unusual mental condition/ability which crosses over the senses. The person in a state of synesthesia will experience a colour when smelling a scent or hearing a word, or associate textures and colours to numbers or letters. I think that the ability some people have to get mental images when listening to music is probably a mild form of it too.

When I photograph, it is an intensely personal experience; I am trying to record the 'mood' of it and to convey it to someone at a later date. I have no idea when I take the picture if anyone else will feel the same as I do about the things I see, as I am not always able to describe what that mood is, but I learned many years ago that putting emotion into my pictures made the viewer also experience an emotion. The viewer may not necessarily experience the same emotion, but will definitely be affected.

How much of yourself you are willing to put into your pictures to attain the correct 'mood' is a decision which only you can make. As far as the technicalities of putting mood into a picture go, making an unmanipulated 'straight' print will, in most cases, produce a picture with very little or no mood at all.

Often, the perceived mood of a picture can be improved simply by choosing some unimportant areas of the picture and darkening them down. This can be combined with a slight brightening of the important areas. These two simple alterations will, if done well, improve the viewer's interpretation of the image. They will not be aware that you are steering them in this way, their perception will simply be of a more powerful, 'moody' picture. This is not quite the same as expressing your emotions through the pictures however, this aspect of the mood content of the picture can not be taught.

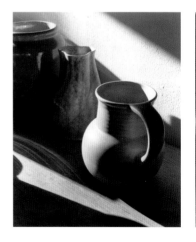 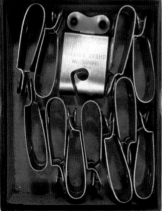

Jugs in sunlight. This was not set up, just photographed exactly as seen. The jug handle and the two patches of sunlight are the most important elements in this shot. The light creates the mood.
Film clips in an old box. *These came with some old darkroom equipment that I was given. I knew as soon as I opened the box that there was a picture here. This is how they appeared, nothing has been altered. The mood comes from the bright shapes against a dark background.*
Little lighthouse. *Opposite. Another image photographed 'as seen'. My children had dropped the small lighthouse on the floor and the shadow of the plantpot on the windowsill made the light appear to emanate from it. The grain of the wood is also suggestive of waves.*

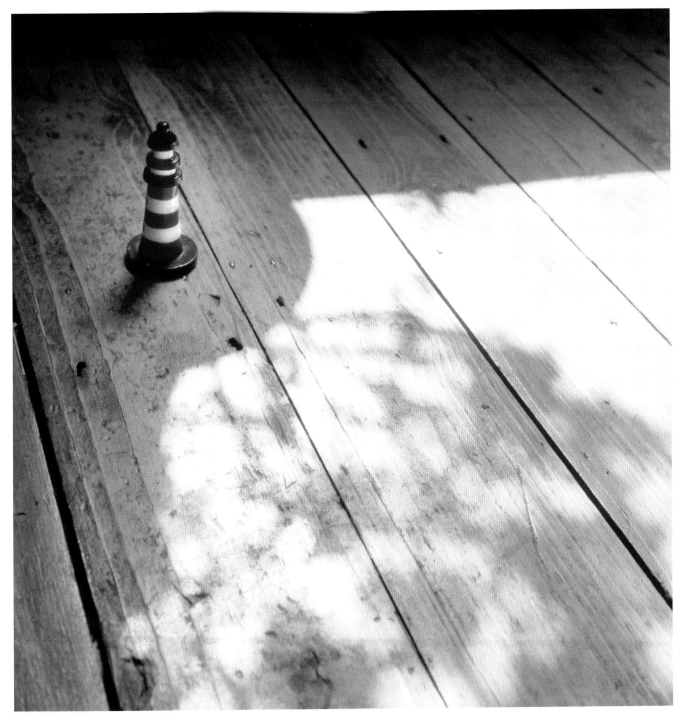

23

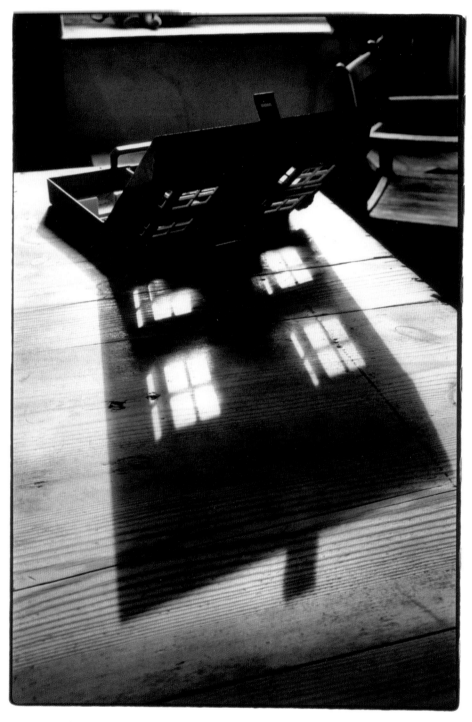

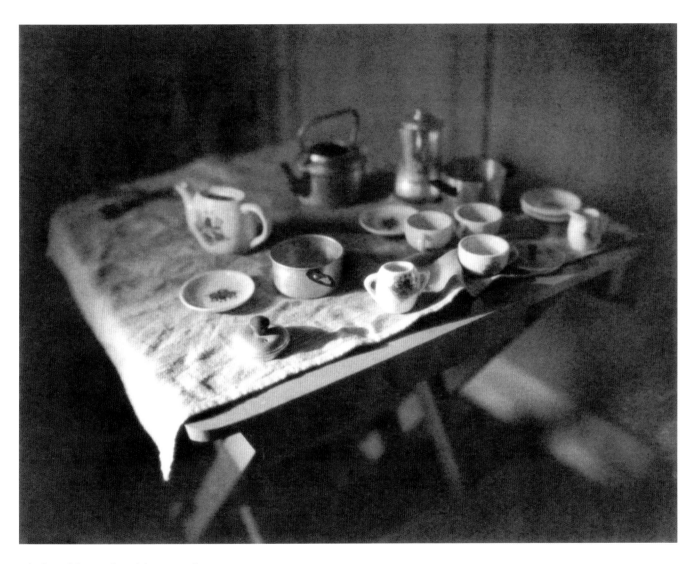

Shadow of house shaped box. *Opposite*
Childs tea set. *Above. The oddness of the scale In
this picture is part of it's charm.*

3 - The room space

The simple act of moving the lighting to another position may be enough to create a change in the picture potential of the space, and allow you to see it afresh.

Where are you now? You could be reading this in a bookshop, but it is more likely that you are at home, in your living room. Your room is a very familiar place, and it is precisely because of its familiarity that it becomes a really difficult subject to photograph. Taking pictures in other peoples' houses is much easier. Seeing the room from a visitor's perspective brings a greater degree of inspiration.

I find that my most inspired moments at home are when something has changed, either when the furniture and ornaments have been moved to another position, or simply when the lighting is different because of a change in the seasons. In winter the tree outside my window is without foliage and this allows more light into the room, but the light is often flat when the sky is grey. A layer of snow outside will reflect light up onto the ceiling, and in summer strong shafts of sunlight pick out certain features and cast interesting shadows.

Creative interior photography is not restricted to the hours of daylight; artificial light from various points in the room will change the space completely and can be positioned to make the place romantic, theatrical, moody, bright, modern or old-fashioned. Flash is to be avoided for shooting indoors, the usual position on the top of the camera may be the most convenient for taking family snaps, but for creative interior images it is the least exciting option. On camera flash kills the mood of a room and the picture becomes a record of the scene rather than a creatively lit image.

Flash can be used off camera for a more interesting effect, but without the luxury of polaroid for checking, it can be a very unpredictable form of lighting, often throwing ugly shadows. Torch light, when used to expose a shot, provides an interesting and unusual effect. The technique involves setting the camera on a tripod, turning all the lights out so that the room is totally dark, opening the shutter on 'B' and using the torch to illuminate various things around the room. This is known as 'painting with light'. If the torch is used around the edges of sofas, ornaments, pictures and doors, it can give a very unusual lighting effect.

Plant shadows.
The shadows in the background appear as a double exposure because the sunlight was being reflected from another window. The plants in shadow in the foreground add contrast and frame the other shapes well.

26

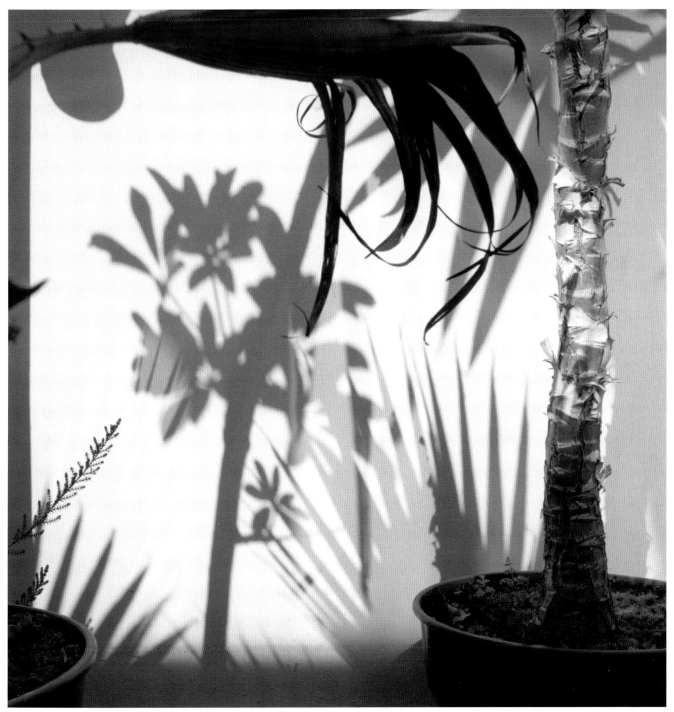

Filtering

The hardest part of being a photographer is the filtering system one has to employ to refine the vision. We are overwhelmed with visual stimuli, large and small, dark and light, moving and still, near and far, natural and man made. There is not enough film in the world to photograph every possible detail, or permutation, of every event or scene that passes before our eyes in a day.

Our brain filters a lot of it out for us, without us being conscious of it. We think that we see things, but most of the time we don't. When we travel a familiar route, for instance, and one day there is a space where some buildings have been demolished, we have difficulty remembering what was there. A variation on this effect is utilized in the parlour game where objects are displayed on a tray and one by one they are removed when the subject looks away. The subject then has to guess what has been removed.

To refine our vision, we must first see everything to decide what is of use and what is not. This means we have to learn to see those things that the mind would normally keep from us. The unconscious mind works in our best interest, it does things to make our life easier, it decides that a large portion of the information we are faced with each day is best ignored.

Each time you enter your kitchen or living room you don't have to study every item, you don't have to investigate how each thing looks and feels, you already know all this, so the unconscious goes: 'yes, this is all familiar, I know all about these things, nothing to concern us here, no need to draw attention to anything' – but if any one thing is changed, it picks up that something is different. Or, if you normally have noise constantly in the background, like a loud ticking clock or a busy road outside, visitors will comment on the sound that you probably no longer hear. If you enter the room one day and the noise is not there, you notice it! That is a familiar situation for most people, and visually our minds work exactly the same way. We become so familiar with our surroundings that we don't see most of it.

Seeing pictures in a familiar space is only difficult if you don't consciously decide to open your eyes and see what is really there. For those of you who have a bit of a visual blockage, looking at your room through a mirror is a good way to start. Hold it up close to your face and walk around the room (carefully) looking at how different everything looks when laterally reversed.

With this technique you will begin to notice how certain things are emphasized, things that you previously overlooked. Users of cameras with waist level viewfinders – medium format cameras mainly – will be familiar with this. The image in the viewfinder of these cameras gives a laterally reversed image, though the photograph is produced the correct way round. This image reversal takes some time to get accustomed to, but when looking around via the camera viewfinder, fresh ideas are produced and new possibilities present themselves because the reversal presents the familiar as unfamiliar.

Micks chair. *Opposite. I was drawn to the vertical and diagonal shapes.*
Reading lamp. *Page 30. I underexposed to make the small holes more obvious.*
Kitchen table. *Page 31. Another shot which is purely about verticals and diagonals.*

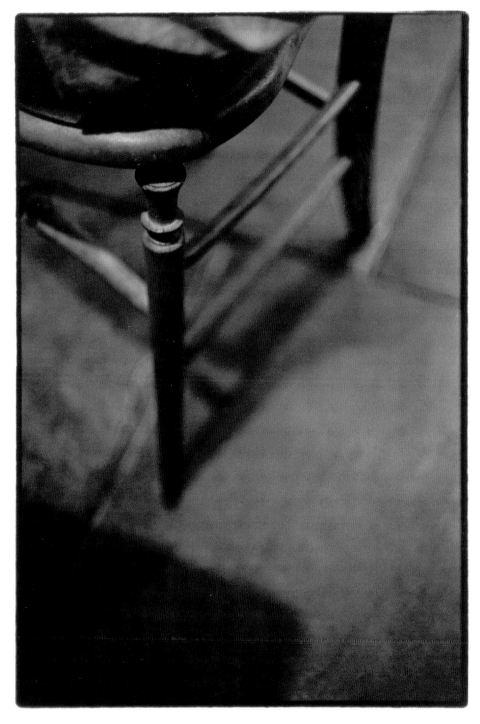

29

4 - Wading through clichés

We work our way through the accepted subjects and eventually come out of the other side.

Do you want to make strong pictures? Have you taken any, or should I say, created any of your own yet, or are you just starting?

As beginners in photography, we are drawn to the obvious subjects, things like kittens in baskets and sunsets. After we have exhausted these sources of beauty we have to look elsewhere for inspiration: 'Now then, what else is beautiful? Trees!' and so on. We work our way through the accepted subjects and eventually come out on the other side, noticing beauty in virtually everything. Photography at this point becomes personal, you begin to photograph the things that affect you, not the things that you are expected to (camera clubs please take note). Photography becomes a celebration of life (sorry, I've resorted to written clichés instead now!). Mainly, you are what you shoot – or should I say, you shoot what you are. You are drawn to things that resonate with something inside.

Photography is not a purely technical activity: it works best when you put something of yourself into it. By definition this means each photographer produces something unique. This is why a number of photographers would produce a different image from the same subject, each would see or feel something that affected them personally. Not many photographers produce something original though. We are all influenced by what has gone before, whether we like it or not.

Many who are new to photography see work by the great exponents of the art and are inspired to copy or mimic. Some become proficient in their technique, and produce work of excellent quality, but because the pictures are not personal, they lack a vitality and character which no amount of technical ability can replace. When I began my obsession with photography, I came across books and magazines showing the work of great (and some not so great) photographers, and found myself heavily influenced by some of the best of them. I would deliberately copy the work of some of the photographers, until I realized that my efforts were just shadows of the originals, and I would be annoyed with myself for wasting time and creative energy on such futile pursuits. After all, how can you hope to create anything better than the person who originated the style? Especially if they have had ten or twenty years to perfect it.

I made a conscious decision at that point to avoid seing other people's work, because I wanted to use my time constructively and to develop a style of my own. This was extremely difficult to do, because I love looking at photographs as well as creating them, and after a while I had to admit defeat – I couldn't avoid other photographers. I needed to approach the problem in a different way. I figured that going to the other extreme and exposing myself to as much as possible, and from as diverse a range of photographers as possible, would actually be an advantage. I would have so many influences at once that I wouldn't be drawn into copying any one style. This proved to be the case, and one of the most valuable things that came from it was an excitement, a realization that anything is possible. There are so many excellent photographers in the world, all doing different things – sometimes unexpected things with photography – and this gave me the freedom to create in my own way.

So I would urge you to look at lots of other photographer's work. You don't need to copy, you just absorb the energy that comes from looking at good photography, and you will find, as I did, that your pictures will be different from the ones you are excited about, because photography is as personal as your own taste in music or the interior of your house. The elements that give your pictures strength are the same as those that determine your character.

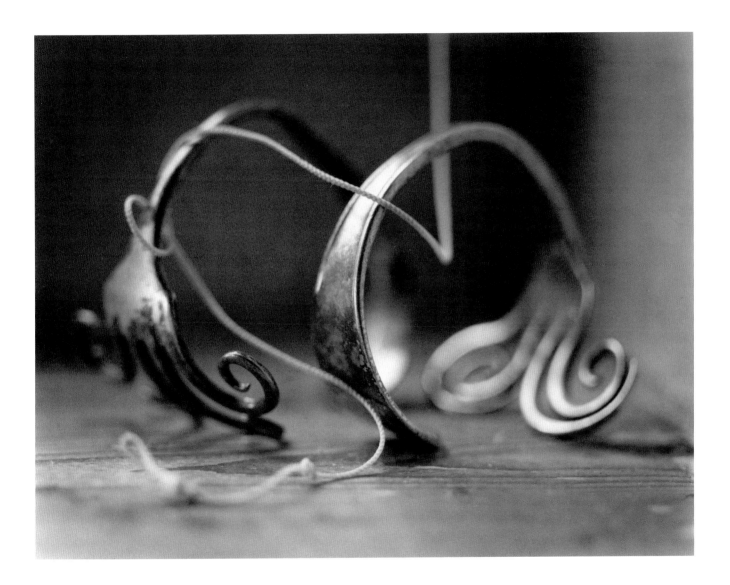

To waste a frame?

Sometimes experiences which provoke strong feelings produce poor pictures, whilst seemingly unimportant events give birth to excellent photographs. Visiting places which have a reputation for being spectacular can produce disappointing photographs. This may be due to the place being photographed too many times, or it maybe that the magic of the place is due to more than just the visual. Finding something or somewhere that is considered too ordinary for photography can provide a pleasant surprise, but it is easy to overlook them.

Quite a number of my images nearly didn't get to the finishing line. I can recall clearly thinking about whether I should or should not bother to use a frame of film on a particular scene, deciding, 'what the heck, it's just one frame', and that image being the best on the film. One or two that I can recall have become very popular images, selling many times.

Thinking back, I question my indecision: why did I dither? I know for some that I felt they were too easy to take, and I equate that with the cliché type of picture, and if there is no effort involved, then surely the satisfaction will be less? Perhaps it was for reasons of economy. As an 'art' photographer rather than a purely commercial one, I have had many years of financial hardship (certainly the

first ten). I have had to strike a difficult balance between taking as few frames as possible to conserve materials, and as many as it takes to get the result. Now that times are much better, this method or thinking pattern should no longer be applicable, but I find it persists even though it doesn't make sense anymore. I'm sure it has been the cause of indecision for a number of images, and may have contributed to the loss of some great pictures, but I will never know. I just have to fight the miser in me whenever it gets in the way of a picture. After having this experience a few times, I now try to photograph everything I see.

At times I have just taken a snap as a reminder to do the shot properly at a later date, because I knew that if I didn't, I would completely forget ever having the idea. This was usually done when time was short and was not ideal. I have quite a number of these negatives which are not good enough to exhibit or publish, but too much time has passed since the reminder shot was done, circumstances have changed and it is no longer possible to shoot it properly. Frustrating, but at least I have something.

The thing that I now try to pass on to my students is the importance of shooting the things you see when you see them and doing the job as well as the circumstances permit.

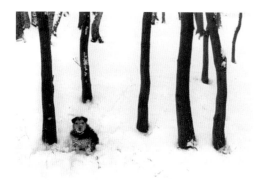

Fork bracelets and string. *Previous page. This was photographed on my kitchen windowsill using natural light. I used a 5x4 camera with the lens at it's widest aperture; this gave me a combination of sharpness and shallow focus. The technique brings a 3D effect where parts come in and out of focus.*
Nellie in the snow. *Left.*
Wills camera. *Opposite. My son was watching me take photographs at home and wanted to copy me. I made him a camera from cardboard and as he played with it I spotted this picture.*

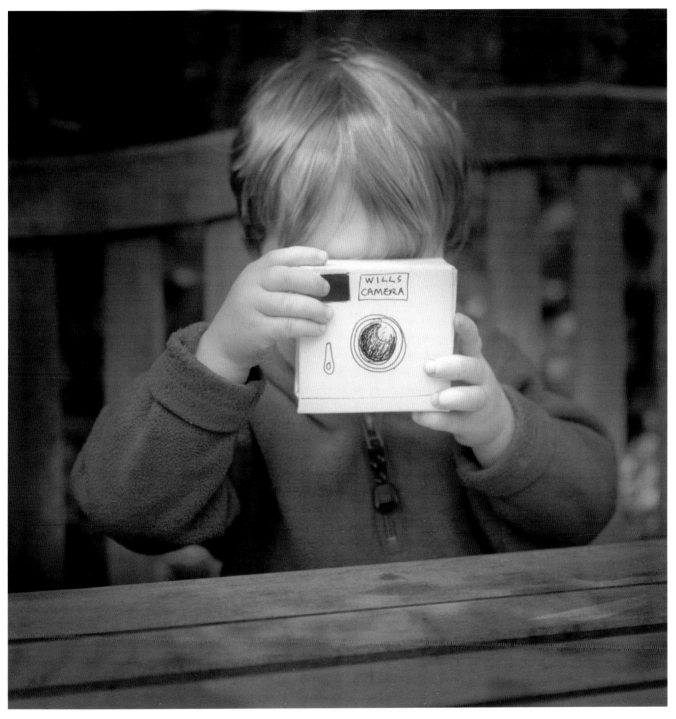

WILLS
CAMERA

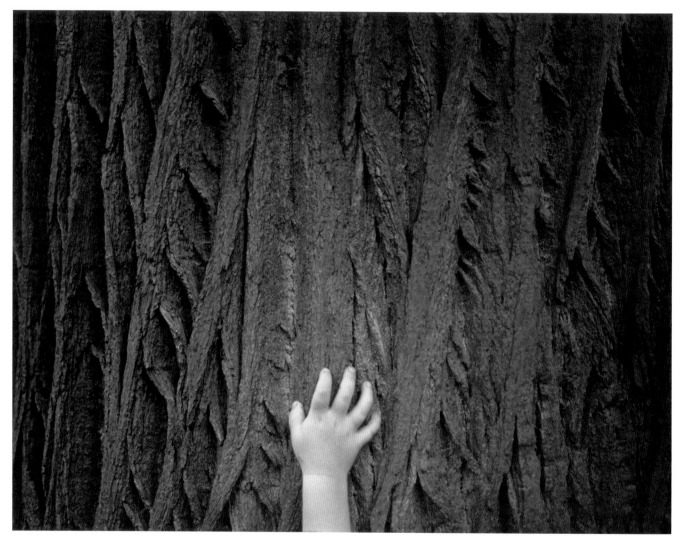

The big tree. *To exaggerate the size of the tree and to give some contrast to the dark bark, I asked my little boy to see how high he could reach up the tree. Cropping most of him out gives more impact.*
Pear and Polaroid. *Opposite. I was trying out some ideas on food photography when this came together.*

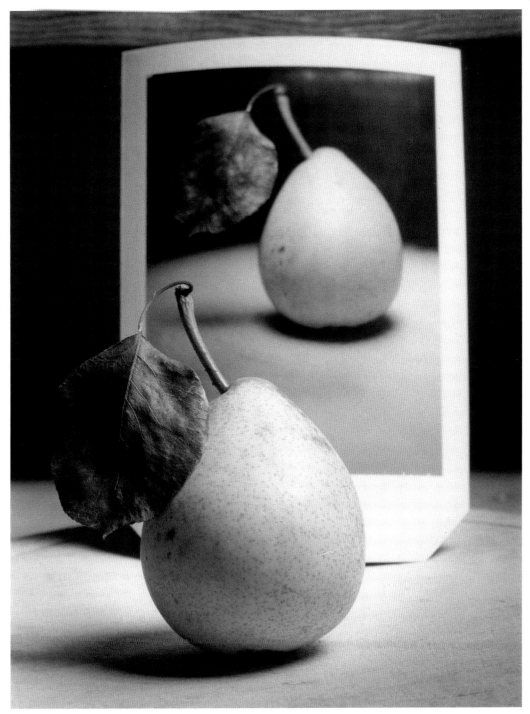

5 - In your kitchen

The kitchen provides a wealth of interesting objects to photograph.

The kitchen provides a wealth of interesting objects to photograph. Food and utensils are all around, and many make strong pictures, either photographed singly or as part of a still life. I have often been halted in the middle of chopping vegetables by the forms and patterns that are revealed. Red onions and red cabbage show very strong lines which are easy to photograph, broccoli and cauliflower look like trees when you get in close. Pasta comes in many interesting shapes, and bread crusts when magnified look like the surface of the moon.

Emmental cheese, as seen in the close up opposite, can look totally different, especially if you see the picture without any other information. This shot often confuses people: I have had some strange and wildly differing interpretations from people who were seeing this print for the first time. 'Boiled eggs in milk', and 'A close up of broken concrete' are two that spring to mind.

Food is only part of the range of subjects available in the kitchen. Utensils, cutlery, gadgets and many other things are waiting to be discovered as pictures.

Chrome utensils are a little tricky to photograph if the reflections are not controlled, but they do produce great contrast and interesting distortions which can appear very abstract. A large chrome kettle when photographed close in will give a reflection similar to the image produced by a fisheye lens. Shiny new spoons give a similar effect. The kitchen gives us many interesting shapes, from the geometry of the furniture to the irregular patterns of condensation running down the windows.

Look again at the things you take for granted, see them in your mind as a black and white print, imagine how they would look in a frame on the wall. Seeing the finished print in your mind before you even lift the camera to your eye is a very good way of increasing your success rate with pictures. You do the editing before you shoot, saving time and money. Whilst you are learning, there will be many occasions when you have an indecisive photo moment. For these I would suggest that you shoot anyway. From this you will learn to recognize the potential (or not) of similar situations in the future, and you may find yourself led into a hitherto undiscovered area of photographic possibilities which could provide many great pictures.

Possible subjects: Onion rings, peelings, eggs, bottles, pepper pot, steamy windows, candles, chrome, vegetables, liquids.

Technical versus aesthetic

Why is it that a drop in technical quality can often give an increase in aesthetic quality? This is often the case, for instance, with some of the alternative processes such as gum printing or paper negative. Is it an illusion – are we kidding ourselves? Are the alternative processes any better, or are we being too romantic about it, seeing second-rate prints through rose-tinted spectacles?

Once you have seen what has been created by some of the greatest ever printer/photographers using these processes, you will realize that there is no illusion or deceit, there is definitely something magical about a well-crafted print done in one of these techniques. So the question remains: why is there a perceived increase in the quality, if the tonal range has been been reduced and the detail has suffered, sometimes badly?

I believe that it is to do with how we 'read' pictures. Our eyes scan the picture and look for information to help in the understanding of it. If all the detail is there, the eye can skip around until the brain says, 'OK, I've got this one worked out – no need to look again.' But if parts of the image are partially hidden in the lower tones, or the detail is subdued and obscured, then the image becomes more

of a mystery, the brain is never completely satisfied. The viewer is left to interpret the shapes and tones of the image, and the imagination makes up the shortfall. Because the imagination is used, the picture is perceived to have more 'magic', and this adds to the perceived quality, rather than detracts from it.

At the other end of the scale where detail and fine grain are the main point of a photograph, the image had better have something that gives it impact. I have seen technically flawless prints from large format negatives that couldn't be improved on, yet the image has been sterile and lacking in emotional content. Photography is not just about sharpness and fine grain, it must have strength or magic, or some indefinable quality which makes you want to look at it again and again, maybe even to own it.

Alternative processes are not the subject of this book and I am not necessarily suggesting that you should use them. What I am saying is that your perception of quality in your own work should not just be measured by the degree of sharpness you can attain, or how fine your grain is. Quality is not tied to those concepts: it comes from within.

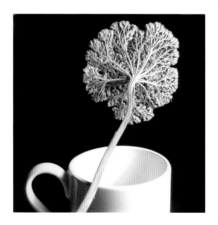 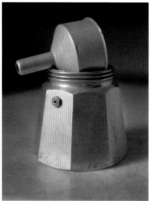

Emmental. Previous page. This was snatched from the table and quickly photographed near the window against a dark background.

Cup and dried flower. Far left. I used the cup to support the stem so that I could see the underside of the dried flower. I preferred it included.

Dalek coffee pot. Left. I had seen this coffee pot hundreds of times, but one day it really looked like a Dalek.

Egg basket. Opposite. The shapes of the eggs were echoed in the wire frame, so I placed it in the sunlight to increase the effect.

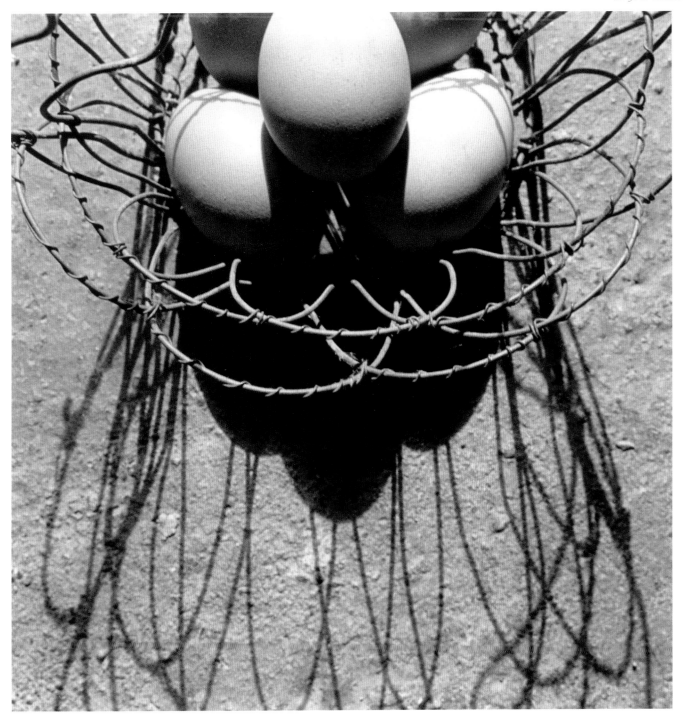

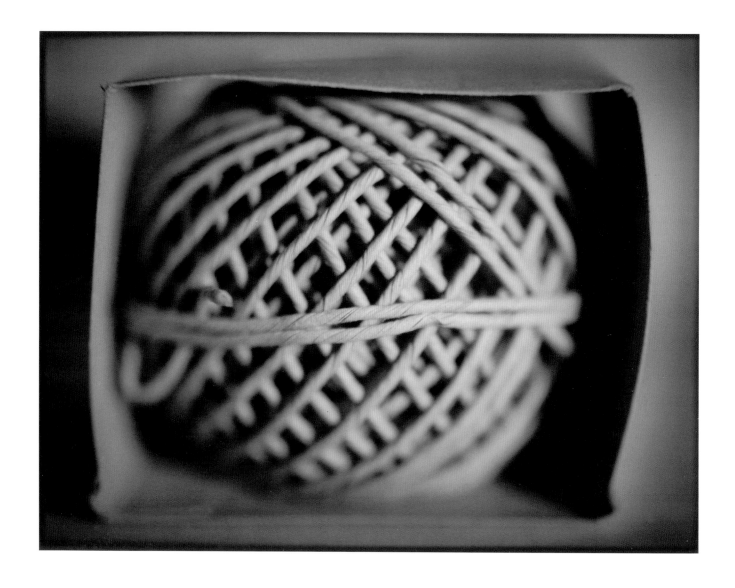

Thrin's string. My friend Thrin was wrapping
Xmas presents at our house and I borrowed the
string for a quick still life.
Jasmine. Opposite. A view of the kitchen window on
paper negative which gives a lovely mottled effect.

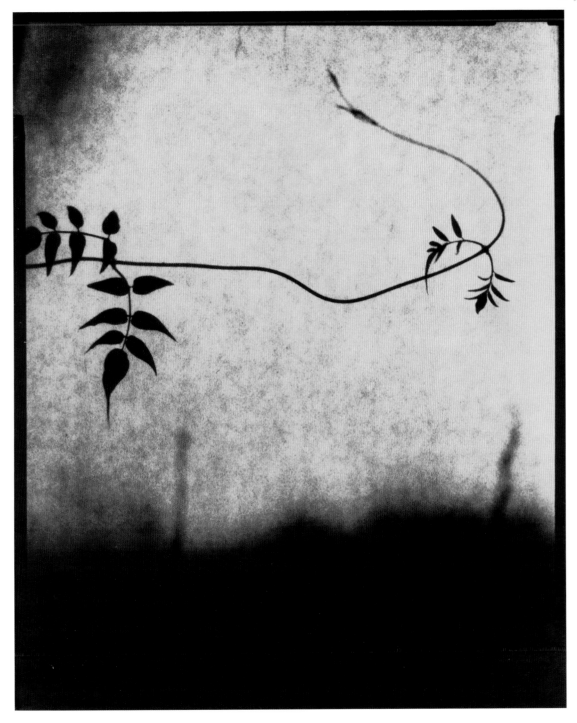

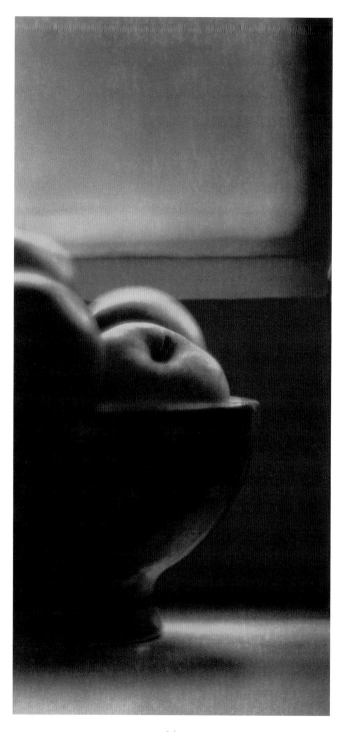

Apple bowl. Backlighting showed the shape of the apples, so I accentuated this with shallow focus and slight underexposure. **Peas.** Opposite. The whole of the information here is conveyed by focusing on one pea pod.

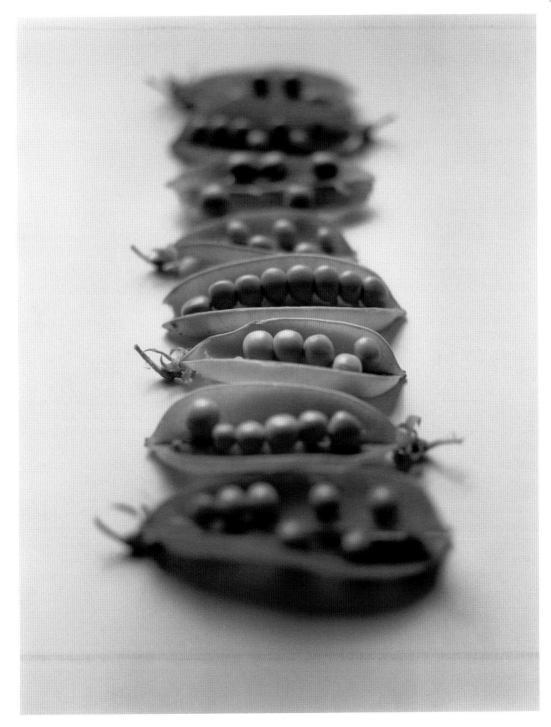

6 - Architecture

Architecture means anything which is part of the fabric of the building.

I have decided to include a section on architecture in this book. This may seem like an odd subject to have in a book dedicated to photographing at home, but the title merely refers to the architecture of your house or the building in which your apartment is situated. Anything which is part of the fabric of that building will come under this heading. This could include the window frames, the staircase, the letterbox, the roof, archways, plasterwork or details in the floorboards. All architectural details are to be considered for possible photographs.

As I have said already, look around at your home. Look for pictures where you have never considered giving anything more than a passing glance. Simple shapes such as the corners of rooms and door frames can be isolated to give a minimalist abstract kind of image; something seemingly insignificant such as the window frame may display interesting details in close-up or provide odd shapes if seen from a different angle. If you have a number of windows, then have a look at all of them and use the one with the best shapes or with the most useful view. Other rooftops or buildings seen from there can be a source of added interest. For instance, a few pointed roofs framed by your window could look like pyramid-shaped objects on your windowsill if taken from the correct position.

Getting into the smaller things of the house – a door handle may cast interesting shadows or have a surface which, when seen magnified, displays an intricate pattern of lines. The taps, for instance, may be quite interesting when photographed close with a macro lens or a wide angle with the facility for close up. This can give a very detailed study of the subject whilst displaying a certain degree of distortion which could be used for interesting results. If close up and distortion effects interest you, then perhaps a pinhole camera is the ideal choice. These can be placed extremely close to things and have a depth of field which extends from almost at the pinhole to infinity.

A pinhole camera effect can be produced by shooting with a super wide lens such as a 14 or 17mm, focusing as close as it will go and stopping the lens down to minimum – this is usually around f32. When the lens is completely stopped down, the depth of field will extend from just in front of the lens to approximately fifty feet away. If the camera is placed very close to objects, the wide angle distortion and extreme depth of field give the impression of a pinhole image. Whichever method you choose, you will notice how easy it is to get pictures which make your place look very different. Try shooting from the plughole of the bath looking up at the taps, or in a plant pot looking up through the plant. You could have one looking out of your letterbox, or on the floor in one corner of the room, pointed at the uppermost corner at the other side of the room giving a very distorted shape to the walls.

One other viewpoint which has not been mentioned so far is the view of the house from outside. I'm sure there are many details or features there that may be isolated or utilized: how would it look through lenses of different focal length? Observe the building whole or in detail at different times during the day for the best option, as the position of the sun will dictate how photogenic the place is. Consider also that the building will look totally different at night when lit by artificial light. This could open up all sorts of picture possibiltiies.

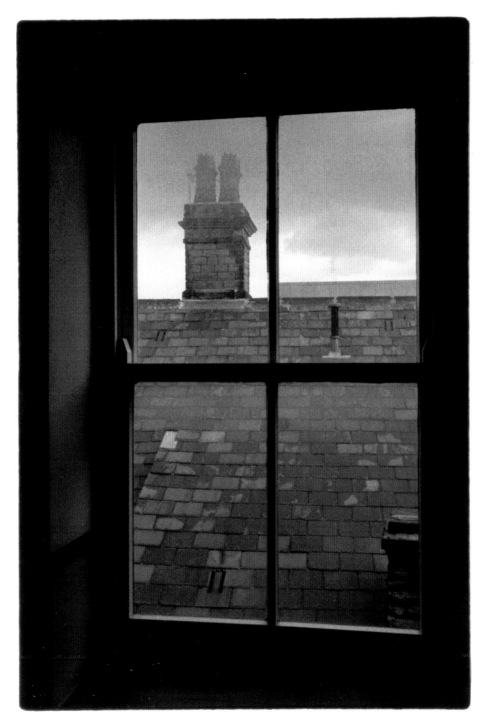

Looking out

What do you see from your front door? I think it's fair to say that you have probably never considered it as a subject to photograph. Each of us has a totally different view, and seen from our own overly familiar perspective it has nothing to offer. Consider, though, an exhibition of images by many photographers, each showing the view from their door. What a diverse and fascinating range there would be, from the corridor of a high rise block of flats to dramatic wide open vistas, and everything in-between. The subject, though banal to the individual, becomes fascinating when seen as a contrast to the situation of others.

The point I am making is that you shouldn't assume that there is nothing of interest in your house. You only see it that way because you are too familiar with it. It could be seen as something totally fascinating to someone from another situation, locality, culture or social class.

Do you see anything from your windows which could be translated into monochrome shapes and tones? If you have more than one window to look out of, then the views are likely to be quite different from each. The direction of sunlight will make a difference to how and when you photograph them. If the sun is behind, or to one side of you, then the view will be clear, as apposed to when the sun shines directly onto the glass. Photographing into the sun will show up all the dirt on the glass, which will obviously degrade the quality of the shot – unless the marks are the subject of the picture of course! – and why not?

Obviously, how near or how far back from the window you stand will alter the framing of the shot. Use the window frame wisely and increase the power of the picture by choosing the best position to shoot from. Tilting the camera will sometimes introduce a sense of movement because it creates a digonal. A strong line across the diagonal from lower left to upper right will give the eye a sense of moving up, whilst a line going the other way, from top left to lower right, will give the impression of movement in a downwards direction. Bear these ideas in mind as you position the camera, and if you are unsure which would be best, then you could easily take one each way and decide at the printing stage.

Consider the view from your place. As you look at it now, it may be just the way you always see it, but try looking at everything with your head in a fixed position and with one eye closed. This will give you a better idea of how the camera will see it. The total area taken in by one eye is roughly that which is seen when looking through a superwide lens. The image you see with your eye, though, does not appear to have any distortion, because your brain alters your perception of it. Nevertheless, it makes a good approximation. How does that look as a potential photograph? If that does not immediately give you any inspiration, then consider subjects which are further away. Using a telephoto lens will isolate things which are of interest. If there are distracting elements within the view, then these can perhaps be minimized at the printing stage, darkened down or cropped out altogether.

Chimney. Previous page. Use the window to frame the view and also to place things in a position where they work best.
Cat on caravan. Look for shapes and contrast all around and be prepared to shoot quickly.

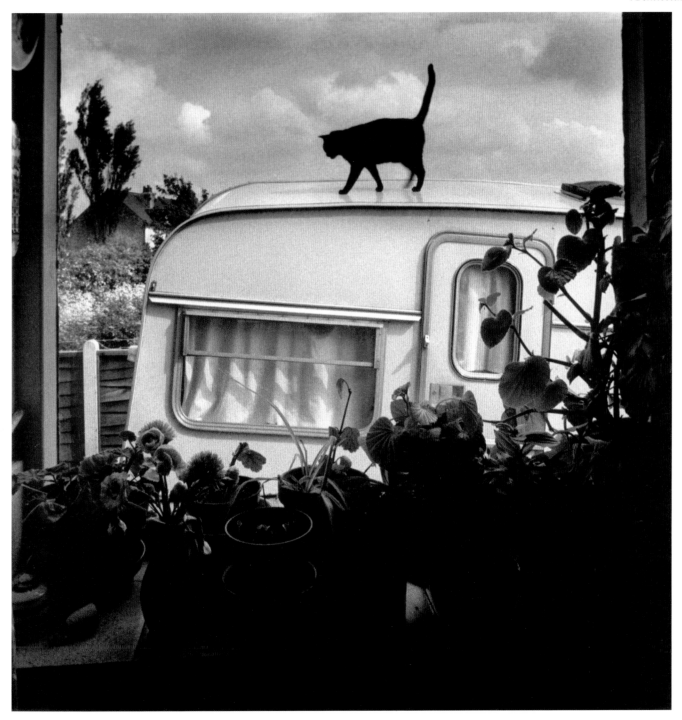

Stuck at home

Although I have been photographing for about twenty-five years, home photography only came into my portfolio during the last four years, when the second of our three children was born. My wife (who is a painter) and I adopted a kind of shift system for our work and family responsibilities, each spending three days a week with the children, and three days doing our own work – Sundays to be reserved for joint family things.

It took some getting used to. Previously I had devoted every day to my work, and could go where the fancy took me. Now I found I was tied to the house, so the time at home was a frustration at first, I felt like a caged animal. I wanted to be out doing landscapes, I could see great lighting effects in the garden and wonderful clouds blowing over, and I couldn't capture it. I was unable to enjoy my children because of my frustrations over my photography. I needed some form of photographic outlet. The solution was simple – take pictures of the children and the garden! Once I had the idea, there was no stopping me, and I have continued to photograph every day, no matter how busy my life has been.

So, for the last four years I would say that I have had fewer than five days out in the field doing landscapes, but instead of being frustrated or being disappointed, I have produced a large body of work which spans flower studies, children's portraits and candids, still life, children's toys, food, kitchen utensils, cloud pictures and more.

None of this would have happened if I had not looked around me, and without it, my frustrations could have easily soured my relationship with my children. For me, home photography has been an interesting and productive diversion, and the work it produced resulted in this book. Who knows what will be created by the readers? I hope the outlet I found and the inspiration it gave me can be passed on and magnified through other photographers.

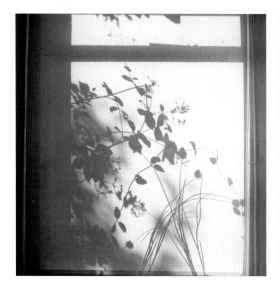
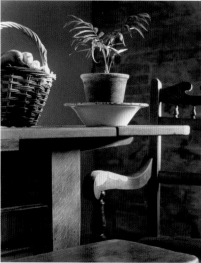

Shadows on blind. *Far left.*
Look for shapes everywhere.
Basket, plant, chair. *Left.*
I moved the fruitbowl into the shot to balance the form of the chair.
Views of home. *Opposite.*
Originally shot for a magazine article on thoughts of home. I used a lens that gave a circular image to create a sense of remembering the scene.

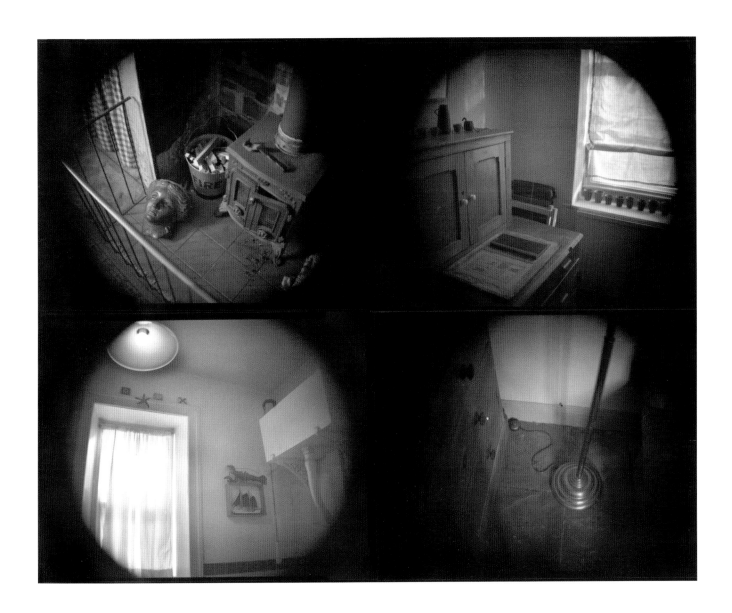

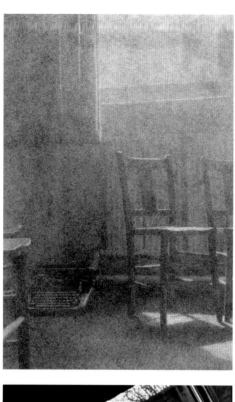

Chair and typewriter. Looking up the stairwell. Dull day. Wooden train tracks.

View through security spyhole. *Opposite. The distortion and softness give a dream-like image.*

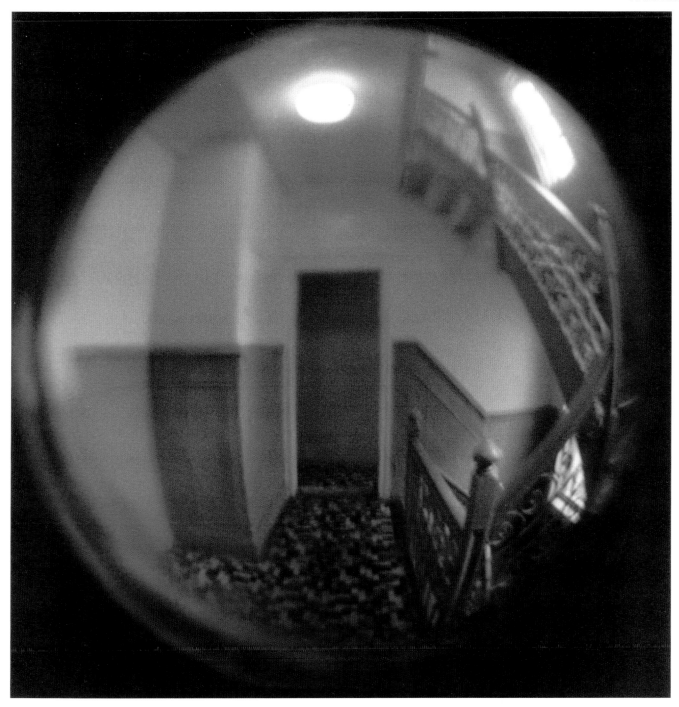

7 - Gardens, plants & flowers

There's more to photographing gardens than making pictures of shrubs and flowers.

Gardens are obviously places to photograph plants and flowers, but they also have many other possible subjects that cannot be found or recreated indoors. Trees are an obvious example: they can be shown in many different ways, in various stages of foliation and at different times of the day (or night), and they are also recognisable if photographed whole or in detail.

Wherever you live, you will have plants or flowers close by. In your garden or in a neighbour's garden, in a nearby park or shop window. Many people enjoy having plants and flowers in and around the house, and these are a rich source of pictures. Flowers can be seen every day, but not very often are they observed really closely. By getting in close and enlarging details, fascinating shapes are revealed.

Photographing plants and flowers is not really that difficult, all that needs to be remembered is to choose a specimen which is as blemish-free as possible and to isolate the part which is of interest. A plain background works best when photographing anything which has many parts; any other detail behind will only cause visual confusion. Lighting need not be too complicated: one light and a reflector for the subject and possibly one other on the background will suffice. Examples can be photographed as they are discovered, or a deliberate long-term project could be envisaged, photographing a specimen from seed to shoot, full plant and finally as a dried flower or seed head.

Even weeds can be photographed to produce interesting pictures. A dandelion clock is an amazing structure when seen greatly magnified, and the leaves have a very jagged edge which works well as a silhouette This can be achieved simply by laying the leaves on top of photographic paper and exposing to light. Take a look around, you will see many fabulous shapes from holly to horse chestnut, from catkins to cabbage leaves. Some of these will work just photographed 'straight', some as silhouettes, and others will work better if light is allowed to show through, for instance to show the veins of the leaf. Take each specimen as a unique subject and study it well before shooting, so as to determine exactly what it is that needs to be said. As you look closely at it, ask yourself: 'What are the features of this plant that say what it is? What are the features that are unusual? What are the features of this plant that look like something else?' And finally, 'What are the features that could look abstract if enlarged?' These four questions will provide enough inspiration to photograph any botanical specimen many times over if applied with an inquisitive eye.

Even something as simple as grass has many interpretations. They can be shown as a close up of three or four strands, or as a large patch of grass blowing in the wind or after heavy rain. Getting low down and close in with a super wide lens, or a pinhole camera, can give a much greater emphasis to the grass, whilst keeping detail into the background. Even a few small bits placed on the glass of a home scanner have possibilities. Try as many variations as you can think of. Not all will make great images, but some most definitely will, and the mistakes will teach you more than the successes.

Dried flowers/seed pods are great to photograph, they do not wilt or die, and can be stored for years if necessary. Most of them bear little resemblance to the main plant and often display dramatic shapes. Some that spring to mind are stinking iris, sycamore, monkey puzzle tree seeds.

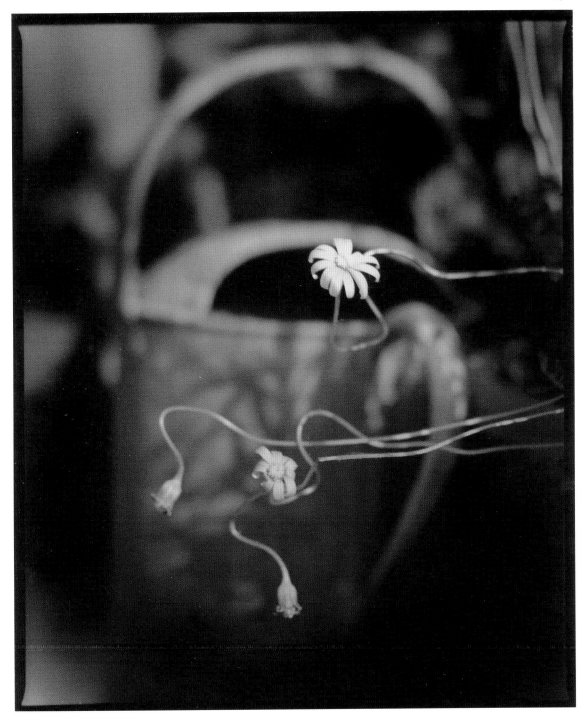

A *few pointers*

I can't give you a set of rules to follow which guarantee success in photography, but I can suggest some ways to approach picture making which could help to elevate your work from the 'snap it and see' method that so many amateurs employ. I have compiled here a number of approaches to shooting and printing which may be used singly, or in combinations, to give your pictures something 'extra'.

The more important points are positioned towards the top of the list, but even the last one will produce the best picture in the right circumstances. So, in no particular order:

• Highlight
• Isolate
• Exaggerate
• Contrast
• Place off centre
• Balance
• Darken
• Show movement
• Burn in the corners of the print
• Backlight
• Differential focus
• Utilize shadows

These are not special effects, they are ways to enhance your composition.

You could also ask:
• What is it about the thing/subject/specimen/view in front of me which is important/striking?
• What is it about the thing/subject/specimen/view in front of me which is graphic in shape/form?
• What is it about the thing/subject/specimen/view in front of me which, when isolated, will tell the whole?
• What is it about the thing/subject/specimen/view in front of me which is humorous/similar to something else?
• What is it about the thing/subject/specimen/view in front of me which is unnecessary and can be darkened/removed/put out of focus/excluded from the frame/diminished in scale?
• What is it about this camera/lens that is unique?
• Can I achieve the effect I envisage with the equipment I currently have? (Be honest.)
• Would this subject be improved if the lighting were changed?

This list is not necessarily to be applied to each image you take. I only offer it as a visualizing aid that can be referred to in situations when you need to kick start an image which you may have got stuck with.

In most situations you will find it too time consuming to read through this list before taking each shot. If you can perhaps keep a few of them in your head, then you may find yourself applying them without thinking about it.

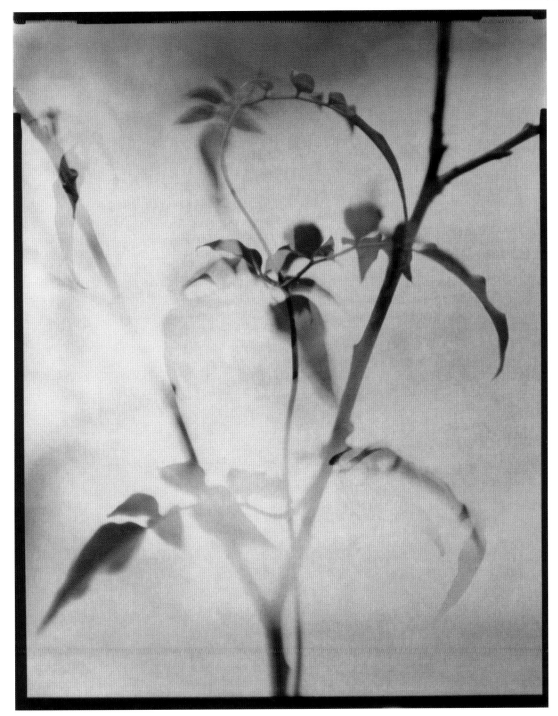

An accumulation of subtleties

Some decisions will have a greater effect on the outcome of the image than others. That is perhaps a rather obvious statement, but allow me to be more specific.

The choice of camera, lens, film, etc. can often be less important than decisions about composition, tone, proportion, subject matter and lighting. We can easily find ourselves getting a little too wrapped up in concerns which have no real bearing on the outcome of the picture. So to take advantage of this perhaps startling fact: the standard of your work will not necessarily depend on your equipment, nor will it depend on your choice of materials as such, it will be most greatly affected by the decisions you make throughout the process from the inspiration to the exhibition.

Try not to fill your head with concerns about equipment. An encyclopaedic knowledge of camera models might impress the younger members of a camera club but won't get you very far when it comes to taking pictures. Just get to know how yours works and put it to work. Use your headspace for thinking about the things which have an influence on the outcome, such as: lighting and selective focus, proportion or emphasis/suppression of parts of the scene to achieve the desired affect which was visualized, how to expose accurately, how to compose pictures, how to print creatively, and useful things like that. These are all choices, and the quality of the outcome depends on you navigating the best route through them. Each choice should be made because it adds to the final image, not just for the sake of it. All of the possible choices that effect the outcome of the image are down to you. Each decision is part of the presentation of the picture. You are presenting your vision and your version of what you saw.

One area of decision making which has an important influence on the finished photograph and which many photographers hand over to someone else is printing. I don't believe that photographers should have their work printed by other people. I say that because the choices made during printing are best made by you, not someone else, no matter how good they are. The more control you have over what is happening, the better. This doesn't mean that only control freaks make good photographers, just that as full an understanding of the craft of photography as possible, and having the greatest degree of control over it, is obviously an advantage. You will find that when you have been responsible for each stage of the process, you take a greater pride in the result because it exists as an end product of all your decisions and efforts.

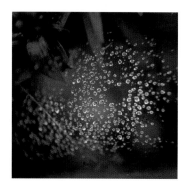 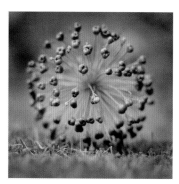 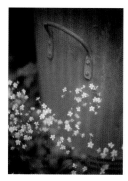

Wet cobweb. Allium seedhead. London pride. *These are all simple pictures, photographed just as I found them in the garden.*
Umbrella plant. *Opposite. I photographed this large pot plant looking through its stems. I used a large format camera (10x8") to give a very shallow area of focus.*

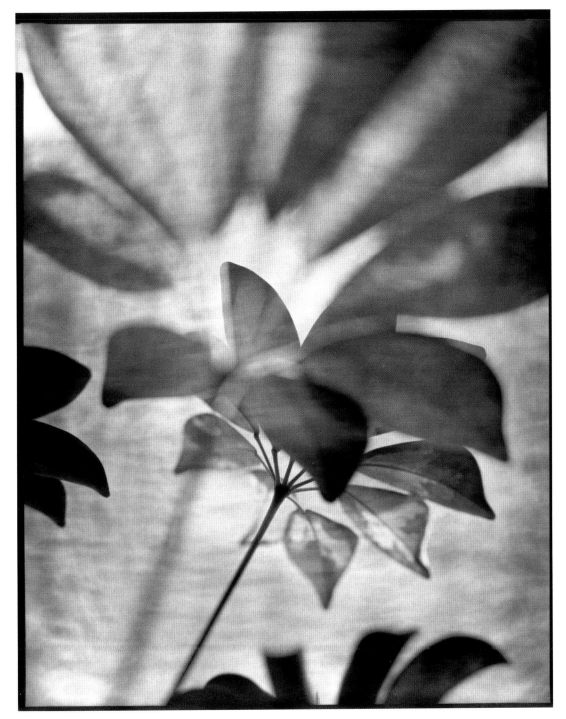

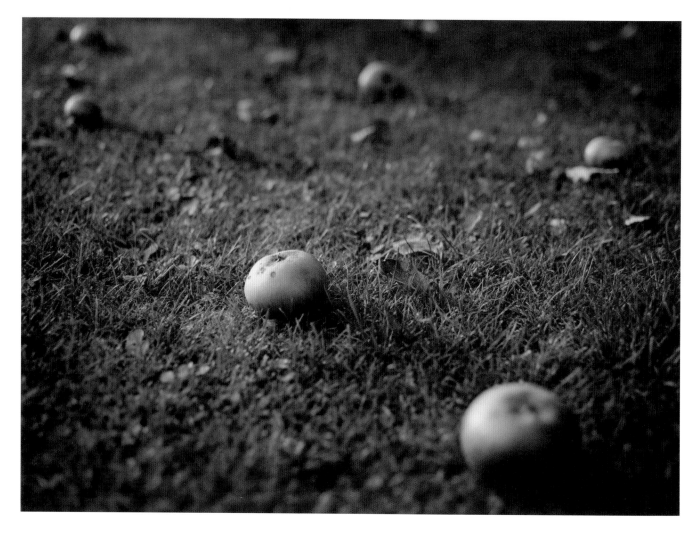

Fallen apples.
An extremely simple picture, I used a short telephoto and shot wide
open at sunset.
Amaryllis in bottle. *Opposite.*
The walls of my old house were uneven and made shadows distort.

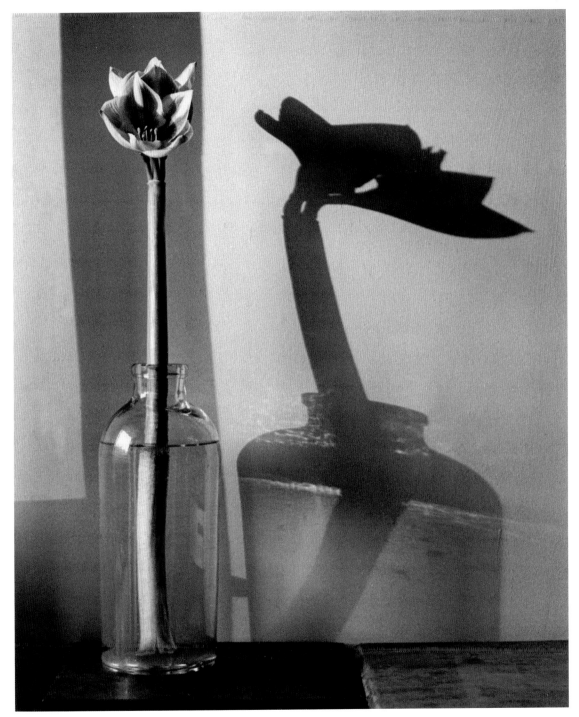

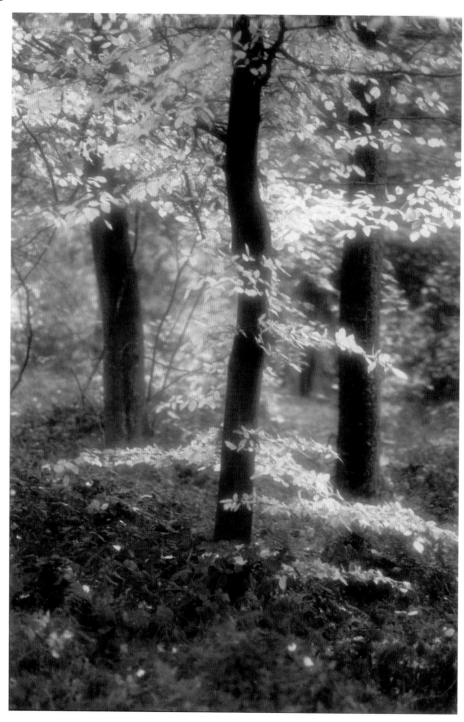

Bright trees.
35mm, red filter in autumn.
Green trees.
Opposite. Quarter plate Thornton pickard, no filter, backlit.
Tuber. *Page 64.*
Teasel. *Page 65.*

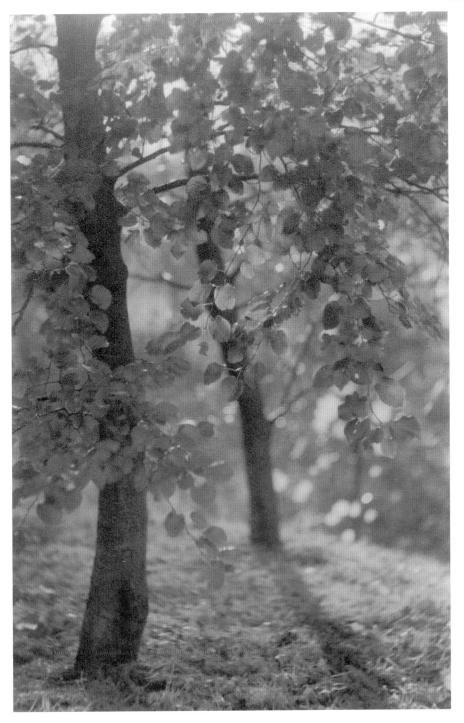

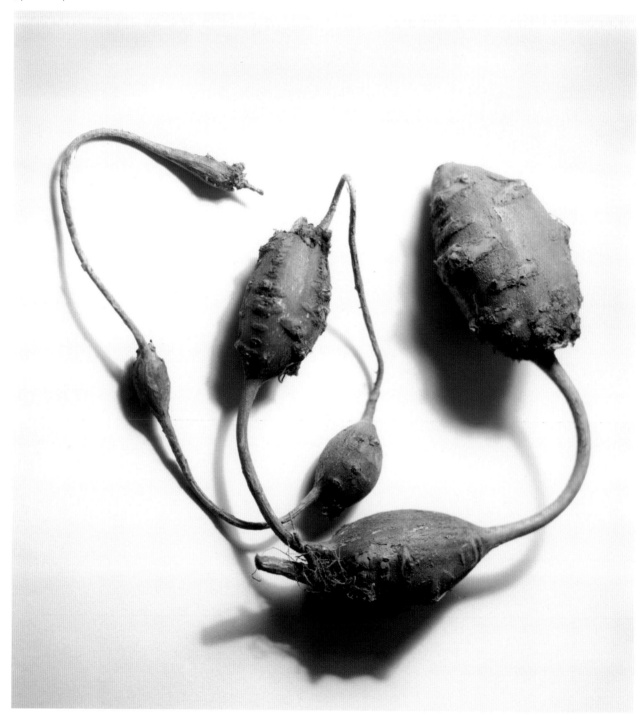

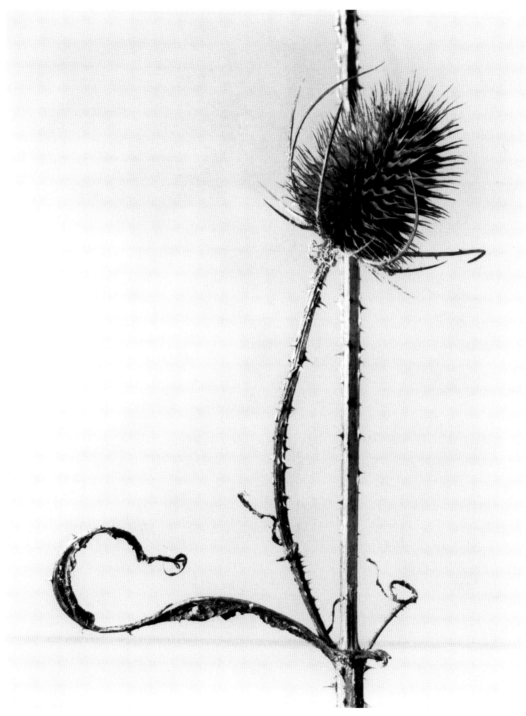

8 - Looking closer

By *observing familiar things in close up, fascinating new ways of seeing will result.*

The intention of this section is to suggest that by observing familiar things in close up, fascinating new ways of seeing will result. Close up, or 'macro' as it is often erroneously referred to, can be used to see hitherto unseen details or to play with ideas of scale. For instance, the old glass marble in the picture opposite, when enlarged, reveals a heavily scarred surface and becomes a little more ambiguous because of the way the image has been cropped. The viewer has no immediate reference to the scale.

Certain subjects have been photographed many times in close up, and I'm thinking here of postage stamps, coins, matchsticks and butterflies. These have been done to death and I believe that many times they are photographed to show off the sharpness of a lens, rather than for creating interesting images. Avoid obvious subjects such as these, and look around for your own inspirations; there is no point in copying tired images – that would just be a technical exercise. A far greater degree of satisfaction comes from choosing and observing your own things.

Close up photography is an area of picture making which has not thrown up much new talent for many years. I can think of only one contemporary photographer who works this way. His name is David Rosenthal and he photographs small plastic figures using a very shallow focus to throw the background completely out. His colour images are usually rather large, which gives the objects a strange quality: the figures begin to look almost real, but at the same time unreal.

This kind of photography is not a technique whereby the subject is 'discovered'. It has to be actively sought out and carefully observed. There are certain technical considerations which need to be taken into account with close up work, the main one is depth of field, which is greatly reduced, and this can cause problems if the shot requires sharpness throughout. This is not absolutely necessary, though, and a shallow or medium depth of field will be fine for most shots. A very shallow focus will in fact create a more 'moody' picture in many instances, whereas the totally sharp shot often looks more like a technical illustration. Another consideration is that, as the object is enlarged, so are any faults or marks. A small scratch will look like a gouge by the time the image is printed, especially if big prints are your thing. A tiny hair could look like a piece of string. If this is a problem, then choose specimens carefully and check them with a magnifying glass.

When you have a few small objects chosen for pictures, look closely at them to find the best angle or most interesting aspect. Move them around, position them on other things or surfaces. Be aware of how they change as they are magnified; leather, wood, fabric, watercolour paper, concrete, sand, all of these surfaces look quite different when used as a base for a close up subject. Skin, especially wrinkled or creased skin, looks very different, sometimes appearing like elephant hide and at other times like cracked mud. If your subjects remind you of other things, then try to put this across in the picture.

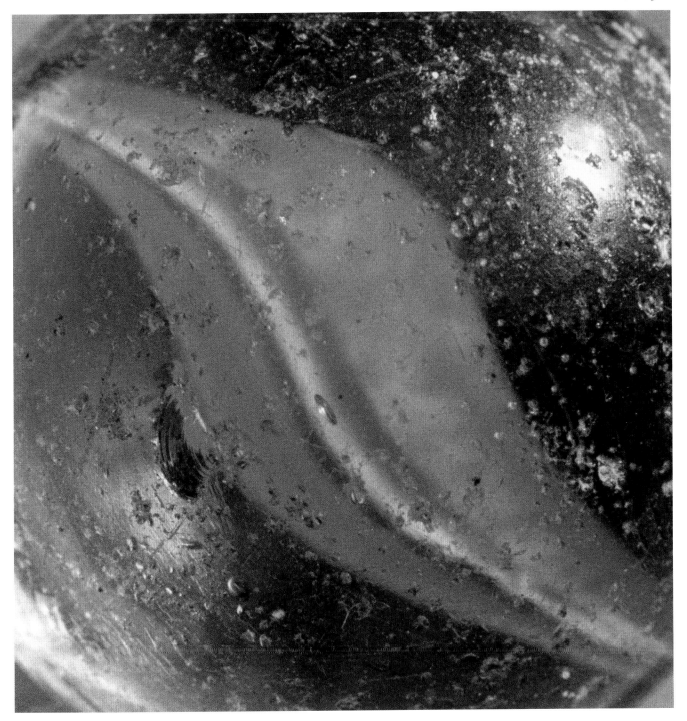

67

Keeping it all in mind

Anyone familiar with photographic magazines and photographic technique books will be aware that in theory there can be many, many elements that go into making a picture that 'works'. Readers are reminded of particular compositional rules, urged to give their pictures meaning, taught about various exposure methods, given instruction on tonal expansion or contraction, told about balancing elements within the frame, instructed about lighting dos and don'ts, influenced about what equipment is best and countless other things too numerous to remember, let alone write here.

It is impossible to remember every photographic rule when out shooting, and things will never be perfect. There will be a car parked in the ideal landscape, a cloud in the wrong place, a telegraph pole or electricity pylon right in the line of fire and a howling gale when a slow shutter speed is needed. Finding ways to disguise or eliminate these distractions is one of the essential skills of a good photographer.

Beginners who submit their best shots to magazines, only to have them unfairly shot down in flames, have my greatest sympathy. Many of the shots are technically good enough, and are only criticized because the writer needs to say something. The fact that this kind of nit-picking criticism probably does a lot of damage to amateurs who have submitted the picture they are most proud of seems to escape the critic.

Amateurs seem to believe that 'real' photographers never make mistakes and that everything is plain sailing for the professionals. This is far from the truth. I know at least three who survive by the skin of their teeth.

Many amateurs would see a big improvement in their work if they stopped reading and worrying so much, and simply went out and shot a mile of film. They would get the valuable first-hand experience, and have a higher number of successful images. The point I am trying to make here is that it is impossible to remember all the rules and permutations of each aspect of photography, about what should and what shouldn't be done in every photographic situation. A lot of it is just learning to trust your own ability, and that, as with so many other things, becomes easier with practice.

I wasn't joking when I suggested shooting a mile of film. The quickest way to learn is to take lots of pictures, but don't do half a job - do it as well as you know you can, which means making an effort, and more importantly, ask yourself the right questions, as I mentioned earlier. Approach your work as a problem to be solved, 'where do I go from here, what can I do to improve my vision/printing/exposures/composition?'

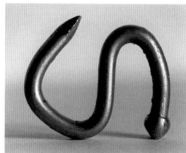

Glass marble. *Previous page.*
Penknife. *Far left.*
Bent nail. *Left.*
Railway whistle. *Opposite.*
When magnified, the fine detail of the scratches and marks tell something of the object's history. This becomes an extra element of interest.

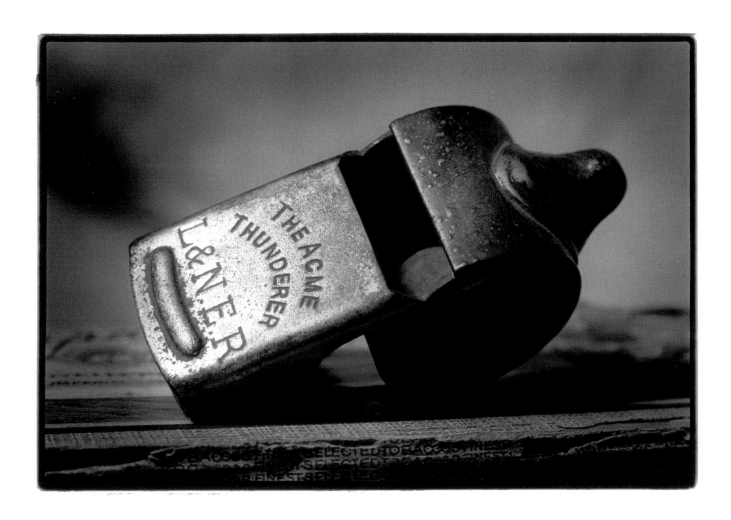

Small things.
I enjoyed the
challenge of a
still life made
up of tiny
objects.
Small pot.
Opposite.
Small flowers
make the scale
confusing.

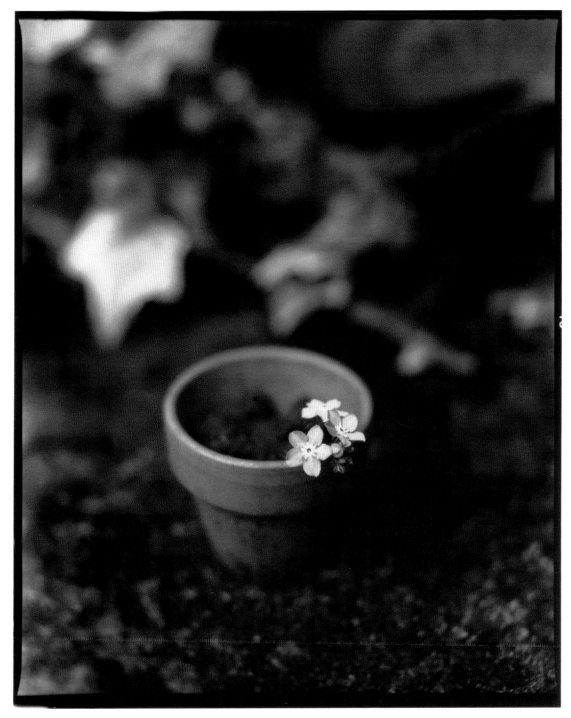

9 - Found objects

Found objects tell a story.

Often out walking I will be stopped in my tracks by something small and rather insignificant.

Somehow this piece of bent wire or shell stands out from everything around it; when the object is observed closely, it takes on a significance, a special quality that is hard to explain. The feeling is so strong that I have to take these things home or back to the studio. Throwing them away would be unthinkable. Some stay as ornaments, whilst others nag at me to photograph them; my studio gets a bit cluttered at times with boxes, drawers and trays containing these unphotographed 'special finds'. These things have an importance about them, there is an excitement in having discovered them, and I try to put that across in my photographs.

Many of you will have experienced this feeling before on a smaller scale, and will have pebbles and shells, maybe even a piece of old driftwood from a seaside holiday. How much more would you collect if you applied your seaside searching vision everywhere you went? What could you find if you really looked? As you look around, bear in mind that many things look far better as a photograph than they do in real life, especially small objects which are seldom looked at in detail. Perhaps it's just that a photograph makes us look again at things we thought were familiar.

I have just taken a break from writing, and as I wandered around the garden with my mug of tea, I spotted a tall foxglove that had fallen, so I cut it into three sections and photographed it on a piece of white card. I set it all up in the doorway where the daylight was directional, and used three other bits of card for reflectors, metered it, and shot it in three ways. The whole exercise only took about fifteen minutes, and I got so involved with it that I forgot to drink my tea.

This little description sums up the way that I generally work, I photograph things when they inspire me and very rarely plan the shot in advance. I generally get through about three or four rolls of film per week, and that is with the minimum of repetition and wastage. If your photography is restricted to weekends, or worse, just holidays, then your chances for creating strong images are severely limited. The part of your brain that recognizes photo opportunities needs regular exercise, and when allowed to lapse, takes quite a long time to get back up to strength. Make sure yours gets plenty of use if you wish to generate an ability to have a kind of automatic recognition of picture possibilities.

Wire, leaf, shell.
I noticed a similarity between the wire and the shell shapes, separated them with a strong diagonal and shot them on an old cigar box.

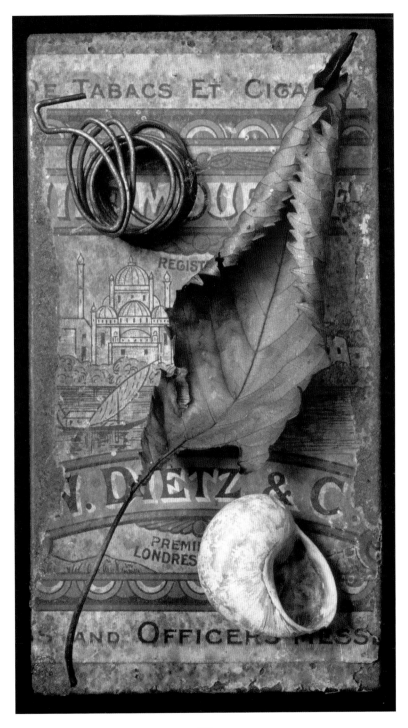

Keeping to your vision

Many times in the past, I have been criticized for not working more to 'themes' and with one definitive style or technique. My reply is usually to the effect that I don't want to, or have to, photograph things in the same way for the rest of my life. If I wanted that kind of rigidity, I would have become an accountant. I am a free spirit, and this is reflected in the diversity of my work.

I see things all the time. I photograph the places I go to, the rooms I am in, the people I meet, things I find on the ground, self portraits, plants, children, night pictures, still life, nudes, the contents of the cutlery drawer, the view out of the window, my feet and hands, bubbles in the washing up, animals, trees, pebbles, architecture and shadows. I do silver prints, paper negatives, gum prints, cyanotypes and gum oil prints, and all of it for the sheer pleasure of creating images. I get excited about anything to do with photography, I can't walk past a photograph without stopping to look at it, especially if it is black and white.

As this book testifies, I see pictures in many everyday situations, for instance, the picture of the coffee pot which looks like a Dalek (perhaps only UK readers will understand the television reference). This is an object which I had used nearly every day and was very familiar with, and yet one day it looked different. I saw it as something new, and had to photograph it. This aspect of photography, the way it makes you see familiar things afresh, appeals to me very much.

It may seem odd to say this now, but, as I often tell my students, photography is not about taking pictures of things, it's about making pictures with shapes and tones, irrespective of the subject matter. When I look around, my eyes are picking up the overall shape of things, though this is largely unconscious. At some point a little switch goes in my head, and this is my signal that my unconscious has spotted a picture. My conscious mind then has to look closely to see what caused the 'switch' to click. When I am satisfied that I have identified it (this only takes a few seconds), I instantly have many possibilities running through my head – pinhole, infra red, paper negative, etc.

Some of these are instantly dismissed because of the limitations of the equipment and materials at hand, but the possible variations are considered with that in mind. Whilst I am running through the options, I am 'drawing boxes' around parts of the scene in my mind: this is to work out the best crop before the shutter is fired, in fact before the camera is even lifted.

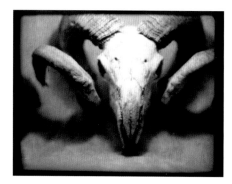

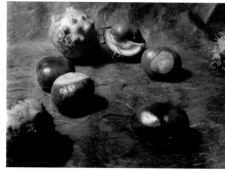

Ram skull. *Far left. Taken on a Thornton pickard quarter plate camera.*
Conkers. *Left. Arranged on a fibrous watercolour paper, lit by a reading lamp.*
Bar, ply, slate. *Opposite. These objects were all found in the same place when I was out walking my dog. I knew as soon as I saw them that they would work well together as a still life.*

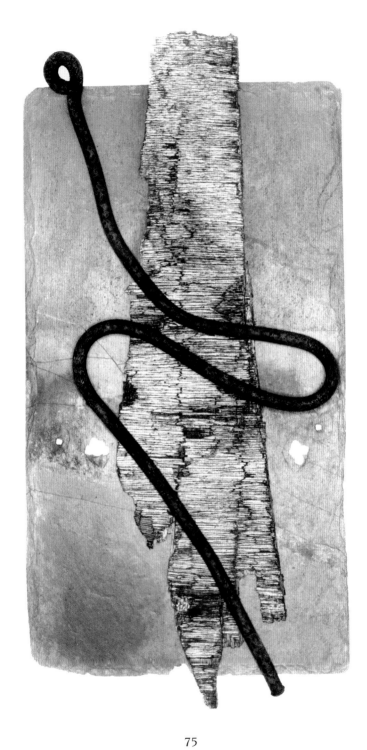

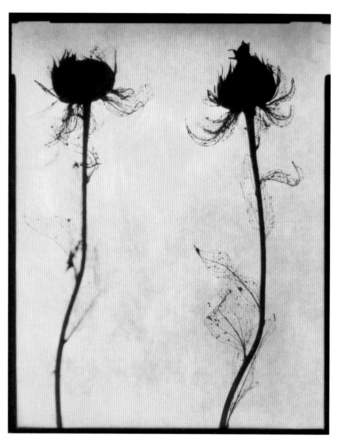

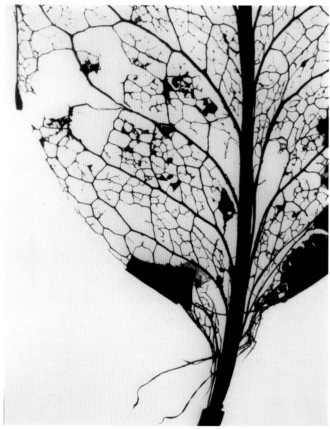

Love-in-the-mist. *Left.*
Leaf skeleton. *Right. Structures such as these work really well as silhouettes, showing the delicate lines.*
Glass fragment. *Opposite. This was found in the wet grass and had small bits of grass stuck to it. I immediately took it back to the darkroom to make a negative from it by projection. It reminds me of insects trapped in amber.*

76

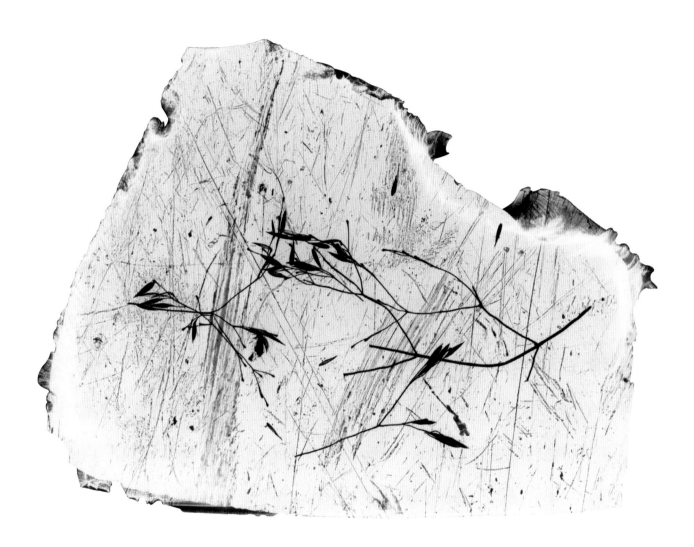

77

10 - People

Your friends, or whoever they may be – gas man, Jehovah's witness canvassers, or whatever – are all different, so why not ask if you can photograph them?

Whenever I have introduced the subject of portraiture as a project for my students, it has caused more unreasonable fear and apprehension than any other topic. The prospect of approaching people (especially strangers) and asking them to sit for a portrait seems to terrify them. Most used to take the easy way out and photograph their spouse – and usually in a rather safe, unimaginative way.

There are so many interesting faces in the world, you could take this as a lifelong subject. Visitors to your home are a great source of portraits, interesting pictures are there if you look for them, your friends, or whoever they may be – gas man, Jehovas witness canvassers, or whatever – are all different, so why not ask if you can photograph them? You may approach this purely as a record of who has visited, in a colour snap kind of way, or you may take the project more seriously. A series of portraits all shot the same way will look quite striking when you have ten or fifteen to show.

It is relatively easy to set up a simple 'studio' for shooting visitors: choose an area of plain wall, or hang a piece of plain cloth over a couple of nails, and ask each visitor to sit in front for a portrait. You could light each one the same, and shoot from exactly the same distance to keep the pictures uniform. This way the differences in the sitters will be thrown into relief. Conversely, your invited visitors could be photographed in a much more natural way as they relaxed in your home, or just as a head and shoulders shot as they stand on your doorstep. However you approach the project, you have the potential for a great body of work. This is an area where I have photographed occasionally, rather than regularly. The pictures I have to illustrate this section come from a selection taken over the years when the fancy took me. Some are of friends who have visited, others of more formal portraits taken either in my home or in theirs. One or two are of people who have called at the door and I have been immediately struck by their looks.

Once you get over the difficulty of approaching people, you will find a rich source of pictures. The thing to remember is to be polite and courteous with every person you are wanting to photograph. Explain that you are a portrait photographer and that you need some pictures of people with interesting faces for your portfolio. Offer to send them a free copy of the print when it is finished. This should be enough to get their interest; you could also have some examples with you to show how you intended to make them look.

I once saw a guy in a pub who I thought looked really interesting and I asked him if I could take his picture, explaining that I was a portrait photographer. He replied: 'If you point that thing at me I'll shove it up your *****!' I explained that I meant no offence and carried on drinking. When a little time had passed and I thought he had probably forgotten my request, I surreptitiously took his picture (his face was too good to miss). The next week I went into the pub with a copy of the print and gave it to him. He was delighted, offered me a drink – and asked if he could have another copy for his mum! The point I am trying to make is that people are not always as fierce as they appear or would have you believe. Many people are very flattered to be asked. Don't be put off asking people with unusual faces: they may look odd to you, but they look perfectly normal to themselves. These are the ones who are going to make the most striking portraits.

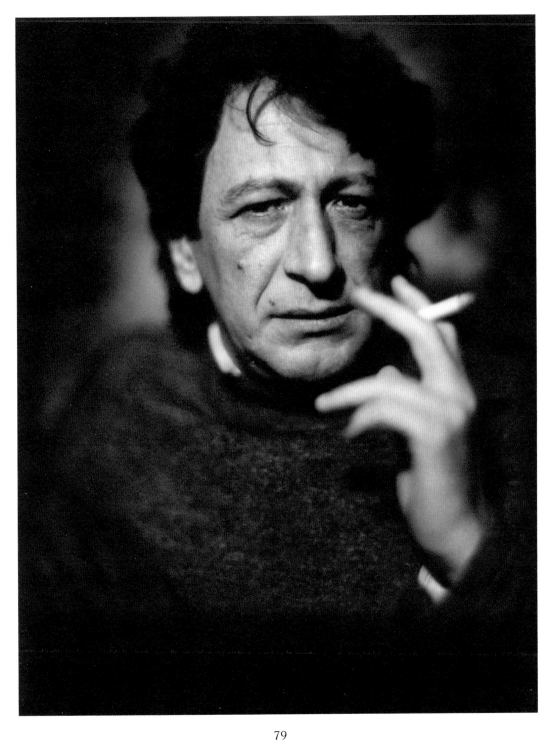

Self portraits

Self portraiture is a great method of exploring ways to photograph people.

As a full time photographer, I am always the one who is called upon to record family events, either in print form or on the video camera. Consequently, I never appear in the pictures; the only decent photographs I have of myself are ones which I have taken.

Self portraiture is a great method of exploring ways to photograph people, as you can try many variations and take as long as you like. You can be as serious (or not) as you fancy, no one is there saying, 'Come on now, be serious, stop pulling that stupid face, are you trying to look like John Wayne/Madonna/Errol Flynn/Marilyn Monroe/Groucho Marx?'

You can photograph yourself working, being sporty, looking important – even totally naked. I have quite a few nude self portraits, mainly because, when out scouting for great landscape locations, I would find some place which I knew would look really good as a backdrop to a nude shot, but there's never a nude about when you need one, so I would strip off and run into the shot as the self timer buzzed away, hurriedly scuttling back into my clothes after the shutter, hoping that no one had seen me! Some of these shots worked, and some looked awful. It is very difficult to shoot yourself when the self timer gives no longer than 10 seconds. You have to run, get into position very quickly, and try not to puff and pant – especially with slow shutter speeds – whilst holding your pose and being conscious of the position of your body, your hands, your head and the leaves on your feet.

Afterwards, when the prints are finished, you may find you get some strange comments when you show them to your friends (if you dare). This was quite difficult for me at first. I am not exactly an unconfident person, but I knew my friends would be having a laugh at my expense. In the event, there were a few jokes, but the general consensus was that they admired my nerve, saying that they didn't know if they themselves would be quite so brave. I took this as a great compliment. I'm not so sure that I should put any of these photographs in this book (as I write I am trying to imagine my parents' reaction); I think I'll restrict it to clothed shots. Besides, seeing my privates is not necessarily going to help you produce better pictures!

Taking pictures of yourself is great fun and has many possibilities: you can shoot yourself in the mirror, or set the camera up on the tripod and use the self timer or a long remote release. Indoors, when the light levels are low, longer exposures are possible and suggest other ways of shooting. Why not try changing your expression half way through the exposure, or moving your eyes about whilst keeping your head still. I'm not going to run off a long list of things to try here, you can do whatever you like, just make sure you enjoy the experience, whatever the outcome.

Enric. *Previous page.*
I love the way the hand is out of focus, even though it is only a few inches from his face.
Legs in mirror. *Opposite. I placed the focus on my legs to draw attention to them.*

Children

Good child photography is possible, but you need a different approach.

The old saying of 'never work with children and animals' is quite good advice. Good photography of children is possible, but they have the capacity to be deliberately awkward at times and often excersise this ability when being photographed. You need a different approach from that used with adults.

Because of the almost total lack of control that the photographer has with this subject, you should not get frustrated about them not behaving or conforming to your ideas for shots. They won't produce pictures when expected to. With children, a commanding or demanding tone will not get you a pliant or subserviant sitter, it is more likely to produce fear or awkwardness – neither being ideal for good portraiture.

The way to get good results is to resist the temptation to direct the action, and to take the position of the passive observer. Sit back and watch the actions and positions they adopt, wait for things to happen, or perhaps I should say, anticipate what is going to happen, because once you have observed it, it is too late to get a good shot of it. You will probably have to shoot for quite a while before they stop being distracted by you and just take you for granted. Once they become unaffected by your presence you will begin to get the more natural kind of images.

One of the hardest things to do (apart from that) is to frame the image properly, as by the time you have zoomed back, or rotated the camera for a change of proportion, the action has passed. The trick is to shoot on medium format whenever possible. I find that shooting on medium format gives me such an increase in quality that I don't have to worry about composition for this kind of work, I just make sure that I have everything in the frame, and crop it in the darkroom later. A 6x7cm negative can be cropped to 30% of it's original size and still beat 35mm, so although the smaller format might seem like the best option with its auto focus and auto exposure, it may actually slow you down.

Using a 6x6 manual camera will make your picture quality improve dramatically, and not only in sharpness – because the cropping is done later, it is far better than a hurried framing done whilst trying to follow the action and stay in focus. A considered approach to the crop which this method provides gives a classier feel to the image, and when you are familiar with how it looks, you will notice how some very famous workers have used the very same technique. Richard Avedon, David Bailey, Albert Watson and others have realized the advantage in not having to worry about framing at the moment of exposure, leaving them free to just focus and follow the subject. This method is ideally suited to photographing people, and especially children.

One difficulty I should mention is that using medium format usually means seeing the image laterally reversed in the viewfinder, so chasing children around the house or garden can be a little tricky if you are unfamiliar with this effect. When the child disappears out of the left of the viewfinder, you have to turn the camera to the right to follow it.

This may be enough to frighten some workers off medium format, but I would say that the quality is worth the effort, and compensating for the reversal is soon second nature.

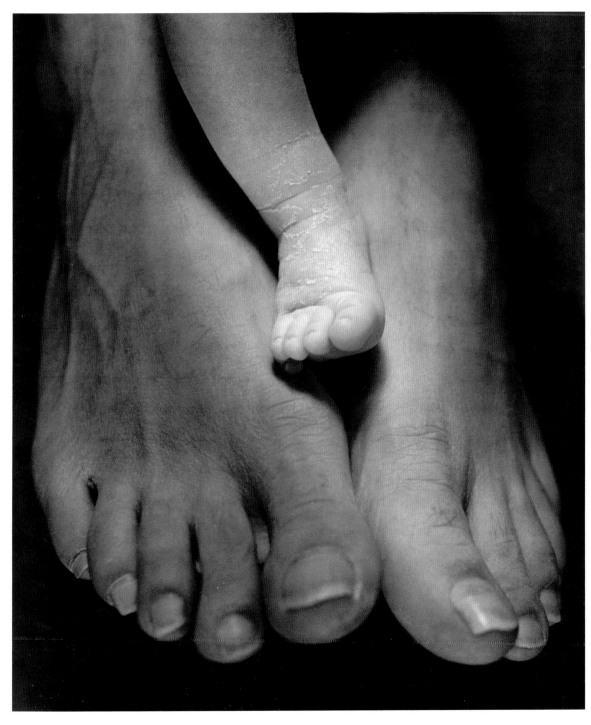

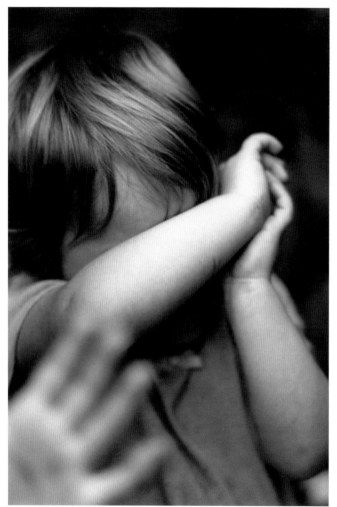

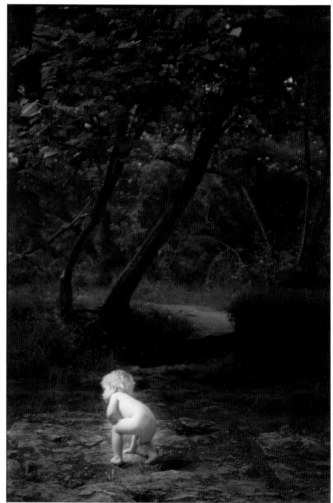

One week old. *Previous page. The large adult feet accentuate the smallness of the baby feet.*
Hiding. *Left.* **Jack.** *Above. Follow the action, don't direct children.*
Alice and book. *Opposite.*
Esther. *Page 86.* **Davey Eustace, Photographer.** *Page 87.*
Photograph your friends when they visit for a range of portraits.

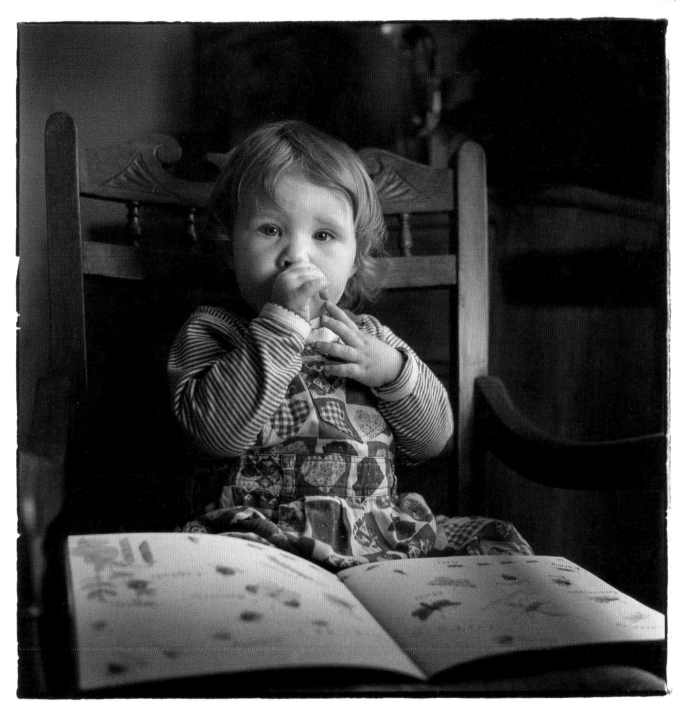

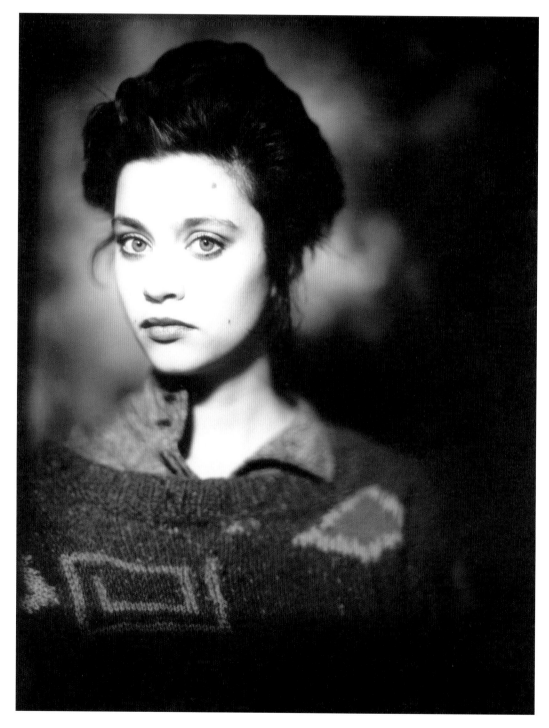

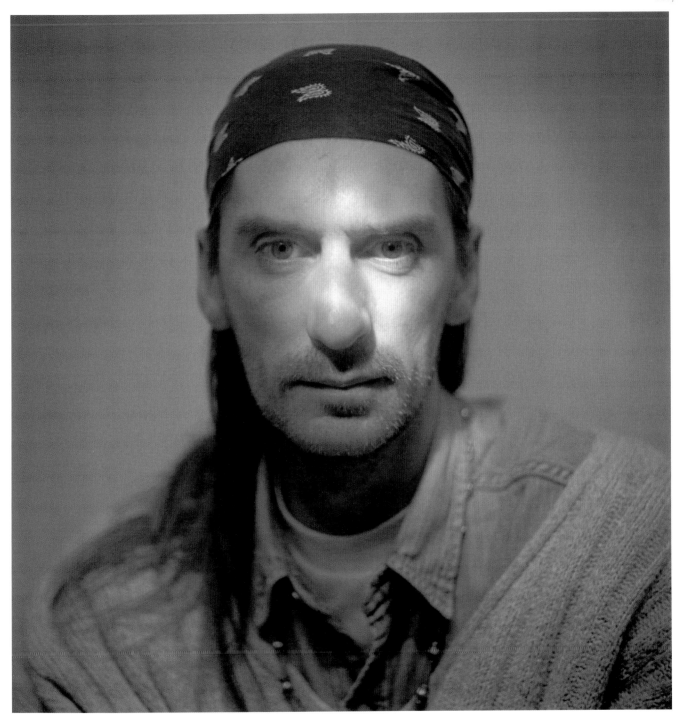

11 - Pets

Animals have been portrayed in every conceivable way, so don't worry about trying to do something different.

Animals have long been subjects for photography and art, and this will no doubt continue. Over the years they have been portrayed in every conceivable way, so I don't worry too much about trying to do something different when photographing them.

My own preference is to bring out the humour which they often display, or to capture an unusual position which they may have adopted. Animals can also be very expressive, and photographing them just at the right moment as they look at you a certain way can create something that goes well beyond the snapshot. This is an area of photography where the photographer has very little control. Great patience is needed at times, as animals are least likely to behave or perform when the camera is waiting. Be ready for the best photo opportunities to happen at the most inconvenient times.

Cats and dogs, being the most common pets, are going to be difficult to photograph if you are trying to do something totally original. Yours will be unique in the sense that your own animal has not been photographed by everyone on the planet with a camera, but don't expect too much from this kind of work, as an awful lot of it comes down to luck.

When taking pictures of animals, it may be that one picture is not enough to convey the various aspects of the personality. Perhaps a sequence of five or six images would be more appropriate, or an ongoing personal project over a number of years which could build into a complete album - or even a book!

One way of working is to get down low to the animal's eye level. Seeing things from their viewpoint will give a change in perspective and alter the emphasis within the picture. Using an extreme wide angle will give a comical distortion to the features, or try taking pictures as they run or play fight. Using a slow shutter speed can produce interesting results, with some parts sharply rendered and others blurred. Try using different methods of working until you get one that produces the kind of picture you had in mind or that conveys whatever it is that makes your pet unique. If you are serious about producing a good picture of your pet, then be prepared to take a large number of photographs – the best shot is unlikely to happen first time.

Small pets such as mice, hamsters and rats will not be great subjects if left in a cage. If the animal is allowed to roam the house, or is comfortable being held, then this is going to broaden the possibilities for a good picture. Larger animals such as horses obviously pose different problems. Whatever your photographic intentions, always consider the feelings of your pet. Animals are easily alarmed if treated in an unfamiliar way, and no picture is worth harming the animal for.

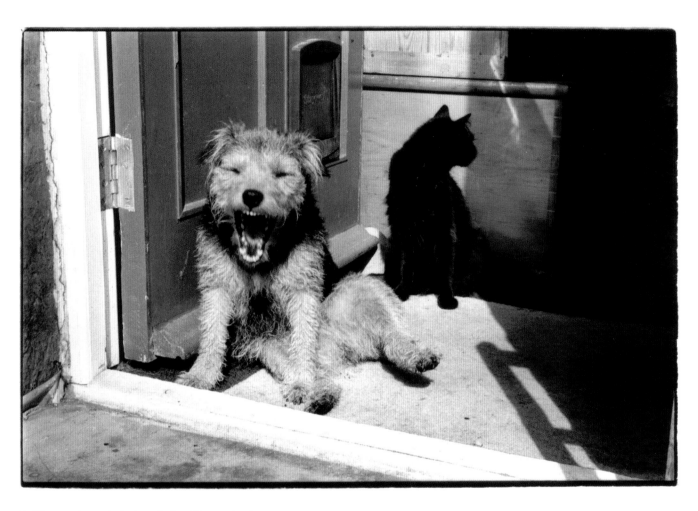

Nellie yawning. *She looks to be laughing or shouting.*

Chickens. *Page 91. The position of them both under the arch of the foliage looked right, but only for a second. It is important to have quick reactions for animal shots.*

What am I *doing wrong?*

Do your pictures disappoint you? Do you remedy this by buying more equipment, going on workshops or following fads? Or do you actually sit down and think, 'What is the problem with my photography, what am I actually doing wrong?' Is it that you are in too much of a rush – snapping away instead of taking the time to consider your photographs? Perhaps you photograph things that have always been shot before, or your vision is too old-fashioned. Does everything have to be a certain way before you feel that photography can be undertaken? Perhaps you are scared of doing it wrong?

All these things and many others are obstacles to good picture making, but by identifying them you can take steps to improve. Be honest about what is wrong with your pictures. Don't kid yourself that you are brilliant if you are not. Don't waste time trying to convince people that they should recognize your genius, but equally, don't set yourself back by asking negative questions such as, 'Why am I rubbish?' This kind of question will not give you an answer that can be used to improve the situation, and is a waste of mental energy. Apply your mind in such a way that it will improve your output significantly; ask yourself questions which have answers that result in you feeling better about your photography.

There may be hidden reasons for your photographic stagnation. It may be that you are not a visual person, some people think in pictures, and some in words, others think in a more physical way. There is much research into this, especially in the US, and it makes fascinating reading. A search on the Web using the keywords auditory, visual, kinaesthetic, or NLP will produce plenty of further reading.

Here are some questions you may wish to ask yourself to enhance what is behind your eye.
• How can I be a better photographer?
• How can I see better?
• How can I print better?
• Is there anything I can do right now to improve?
• How can I improve on my last great picture?
• When have I produced my best work and why?
• Am I better than I was two years ago?

Positively phrased questions such as these may not have an immediate, obvious answer, but they will eventually give you answers that can be used to the good of your work and are better than the self-deprecating messages that many people have circulating in their heads – which only cause dissatisfaction and poor self confidence – change your attitude and you change the way you see. None of us sees the world as it really is, we all filter the messages from our senses through preconceptions, indoctrinations, prejudices and the influences of our culture. You can choose how you see, and getting rid of negative self talk will make a massive difference – I guarantee it!

When things don't go as planned

When you see the results of your photographic exposures, whether that be transparency, colour print or black and white, do you get excited, or do you see a lot of wasted frames?

Don't give yourself a hard time over the ones that didn't work; every photographer has wasted frames, some of the top photographers in the world waste more film on one shoot than you would get through in a year, and often they are only looking to use less than fifteen images from that one shoot. They know that only a small proportion of what goes through the camera is usable, so they shoot as much as they can, and the small proportion of usable shots then amounts to enough to cover the requirements of the job. So don't be afraid to make mistakes: doing things wrong is an essential way to learn a method for doing things right. Your mistakes will sometimes open up other possibilities for you. The result you get when something turns out different than you expected can lead you into another way of working, and this could produce some very interesting results. As a good friend of mine says: 'let the accident participate'.

Some very famous techniques have come from accidents. I'm thinking first and foremost about solarization, which was discovered, legend has it, when someone opened the darkroom door during the development of a print, fogging the highlights. That mistake gave Man Ray one of his most useful techniques and helped to make his name.

I'm not advocating the complete absence of proper technique here; I think that a good knowledge of technique is absolutely essential. I'm only suggesting that you consider the results you get fully before rejecting them. Ask yourself if the result could be used in another context to accentuate another type of picture. It may be that the effect is kind of interesting, but when combined with the right type of image it looks much more impressive. Apart from an open mind towards 'mistakes', a healthy disregard of the established 'rules' about what is acceptable or expected from photography is also worth cultivating, The photography world, and especially photographic clubs of old, abound with unwritten rules about composition, proportion, things coming into a picture or going out of it, whether the foreground should be sharper than the background and many other laws too tedious to mention.

These rules (most deeply ingrained in the minds of club judges, who, strangely, don't seem to be very well known for the quality of their own work) are like invisible ropes that bind you tighter and tighter, until you are unable to do anything.

It is easy to allow yourself to be constricted by other people's opinions, especially in your formative years as a photographer, and to not fully realize your potential. Other people will always have an opinion about what you should or should not do with your photography, but you need to stick like superglue to your vision and your intentions to produce the work which is waiting to come out of you. Imagine what kind of work would have come from Jerry Eullsman, Robert Frank, Sally Mann or Joel Peter Witkin if they had started their photographic lives listening to the opinions of narrow minded stick-in-the muds (if you don't know what kind of work these photographers have created, then I urge you to find out via the internet, or a good library). Bending the rules a little introduces an element of surprise which will eventually give you a wider pallette and a greater chance of having something magic happen. I go back to my earlier point here: experimentation is the key, try everything, see what works for you and use it.

Mollie the cat. *Previous page. The curvature of the semi fisheye lens helps the composition.*
Horse eye. *Left.*
White rat on door. *Above.*
Humph. *Opposite. His eyes looked extra bright as he stared because of his dark fur and the dark background.*

12 - Toys

Often, if things are taken out of context they are transformed, and this can be enough to give a change in perception, and hence the emotional response.

Toys may not seem like ideal subjects for pictures, but if they are photographed with humour, they can become something special, maybe even on occasions something that has impact and longevity.

Toys, certainly ones that are figures or characters, seem to make better pictures if they are photographed in unexpected locations or situations. They can be portrayed as characters in a story or as a metaphor for something else. When they are photographed in this way, they often look more human, and this can make for interesting photographs. Anthropomorphizing them in this way gives the picture more 'life' as long as you avoid the temptation to make them look cute, although even this might work if you were doing it ironically. Often, if things are taken out of context they are transformed, and this can be enough to give a change in perception, and hence the emotional response. This is very easy to do with toys.

Another technique which can alter perception of the subject is scale. Getting lower down gives the impression to the viewer that the object is larger; this is a simple way to give it more importance and drama. Many times they can take on a sinister element, and this can be used to good effect. Dolls, for instance, or puppets, remind us perhaps of old-fashioned horror films. With the application of a little dramatic lighting, let's say a torch from below, the effect can be exaggerated.

One more approach that springs to mind is to go for a full colour image which might present the toy in a way that is more of a comment on consumer culture. Whatever angle you go for, I hope that these suggestions help your visualization. Viewing your potential subjects with these ideas in mind could give you some inspiration, but there may be other kinds of toys in your house which I have not mentioned here that have other possibilities. For instance, do you have any of your old toys still? Could you photograph them in a way that magnified your nostalgia for them, or perhaps as a way of exorcizing bad memories from your childhood. There are many approaches, and you must decide which is best for you.

I have been photographing abandoned and broken toys for a number of years as I discover them. This is a long-term project (as many of mine are), and I don't have any plans to use the pictures for anything. I just enjoy shooting them, and that is the main message of this book, to photograph purely for the fun of it.

Noddy. *Opposite.*
Just as I noticed it. I used a long lens to isolate the subject and darkened the outer edges when printing.
Potential. *Page 99.*
Photographed on the back of an old door panel in my living room.

Being honest with yourself

To increase the frequency of your succesful pictures, and achieve higher and higher standards in your work, you must be self-critical. Do not take that statement to mean that you have to beat yourself up about your shortcomings, self-deprecation is a very negative human characteristic, which produces nothing except a poor self image – which in turn fuels more self-deprecation. Don't go down that road.

The thing we find hardest in life is criticism, we don't like to be told that we drive badly, that we are poor lovers, don't know how to bring up our kids, or have the wrong opinion about politics or religion. So how do we criticize ourselves without taking the easy option? That is obviously to deny that there is anything wrong. If you are of this opinion, then you most definitely need to have a long hard think about how your pictures would look if they were placed beside photographs done by the real masters of the craft. I'm not going to put any names forward here, you have to decide who you respect in the photographic world.

It is very easy to drift along with the minimum of effort, producing mediocre pictures whilst kidding yourself that you are going to be famous. If a top gallery from New York called round while you were out and took away your portfolio (or shoebox – whatever you keep your pictures in), would you be horrified, thinking: I hope they don't look at that print of the..., I never got round to printing it properly, and it has white spots all over it, I wish I had retouched it?

Have your pictures printed to the best of your ability, toned where appropriate, retouched and signed, then you can sit back and relax in the knowledge that you did your best. I'm not setting myself up as Mr Perfect here. I am passing this information on to you because I have had bad experiences in the past, where I didn't put the effort in and thought that no one would notice. Eventually, though, someone does, and it's usually in a situation where you need to make a good impression.

We need to be able to judge our own work with the utmost clarity, to be honest about what needs to be improved. But how? It is not easy to see your own photographs objectively, especially if you have seen them a hundred times before. I find that I have to use my imagination a little bit, and look at what I have printed as if it were by someone else. Then I can say what is right and what is wrong about it. If I imagine it in a magazine or in a book or perhaps a prestigious exhibition, (sometimes this last one is a little too harsh, not many get through this one), I can then get a little distance on it and judging becomes easier. I don't throw away the 'also rans', only the completely duff. I find it is useful to remind myself how far I have come by looking at how bad I used to be. That is not to say that I have 'arrived'. I realize that I can do much better, and that is true of anyone. Photography is a never ending subject, it is never finished or complete, every photographer should strive to improve with each image.

In aiming for perfection, attention to small things – which may not seem too important in themselves – rapidly takes your work into a higher plane; it has an exponential effect. It is the little things which make the difference, an accumulation of subtleties, as I said before. It is the sum of the parts creating more than the whole. If attention is paid to the small things that matter, then this will show in the quality of the finished work.

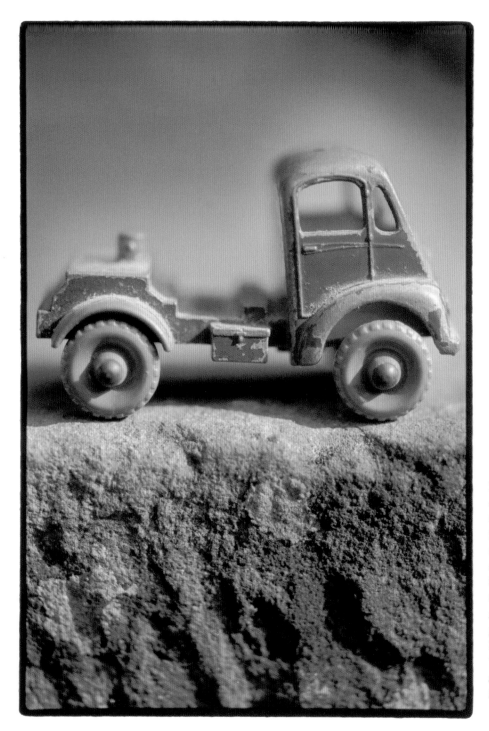

Dinky truck.
A dramatic fall-off in sharpness from a macro lens used at its widest aperture.
Soldier skittles.
Opposite.
A Christmas present for my little girl, 'borrowed' for a still life. Lit by bounced flash.

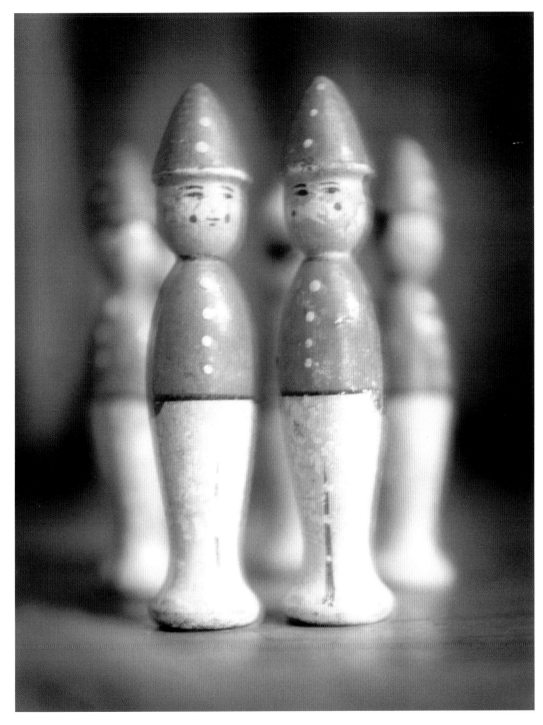

13 - Making pictures happen

Be a little more in control. Make pictures, don't wait for them to happen.

Are you the kind of photographer who waits for inspiration before taking a picture? If you are, then I guess this means that your camera very rarely gets taken out. Perhaps you carry it everywhere in case of sudden unexpected inspiration, or at least you did when you first got it, but now it just seems like too much trouble to carry it. OK, let's be honest, it only comes out on holidays, doesn't it?

Have you considered that you could be a little more in control and instead of waiting for pictures to make themselves known to you, you could make pictures from your current surroundings? Look around the room that you are in at the moment: can you see anything that has been around for a long time and hasn't really been looked at? What is the most banal thing in the room? The more ordinary the subject, the more likely that you have stopped looking at it, looking properly that is – really seeing what is there.

As I sit here at my breakfast table jotting down ideas for this book, I notice crumbs left over from this morning and I think to myself, how could I photograph them and make something interesting? A few possibilities run through my mind: get in close with a macro lens; get in close with a pinhole camera; light them with a strong sidelight to throw long shadows; contact print them onto graphic arts film and then print from that; lay them on the scanner; try them on a white background, or a black; keep all crumbs sharp or have a very shallow focus. I could combine some of these ideas, for instance the macro lens with strong side lighting on a white background, or in close up with a pinhole camera on a black background. I could then choose to print a high contrast version or a normal grade. I might decide to split tone the picture with selenium toner or hand colour them, perhaps both.

As I go through these options, I am seeing the results in my imagination and deciding on the methods which produce the best picture in my head. When I see one that I like, I then begin the process and methods necessary to bring it to fruition. I didn't photograph the crumbs in the end, but decided to include this as an illustration of how I think, so that it may help some readers.

If you have arrived at this point by reading the previous chapters, then you will have got the general idea of the book by now. The message is: pictures are all around you, waiting to be photographed, but you have to find them, think of it as a photographic treasure hunt. Don't tell yourself that there couldn't possibly be any pictures in your place; work on the assumption that there are thousands hidden around the place! The important point is that you should not exclude anything as a possible subject before you have explored the various options.

So what sorts of things should you take pictures of? I can't answer this question, as you can see my problem is quite the reverse - what shouldn't I take pictures of? There is so much out there (and in here) that could be the subject of a photograph. You must shoot the things that you find affecting you, the things that keep popping up like a shooting gallery duck trying to get your attention. I'm talking about things that you may have noticed on many occasions but have never considered photographing. Perhaps this is the direction your photography should go. If you are unsure how to approach your chosen subject, then take some time studying how other photographers have tackled similar subjects in their work. The more you look at work by other photographers (choose good ones), the more you become used to seeing things photographically.

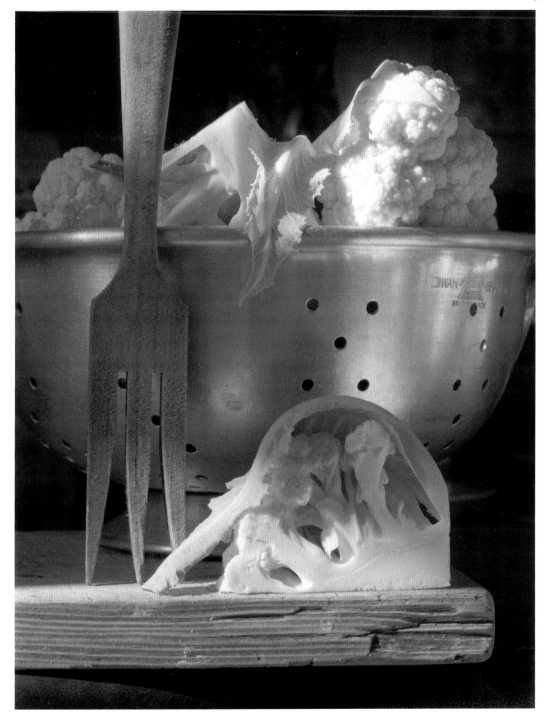

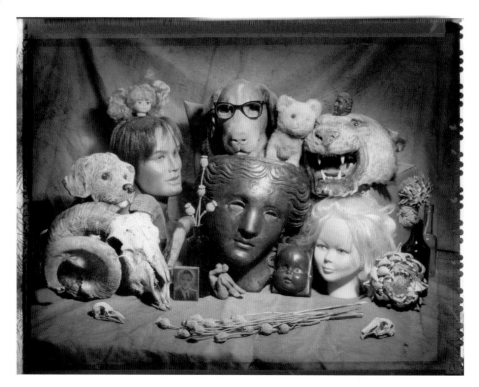

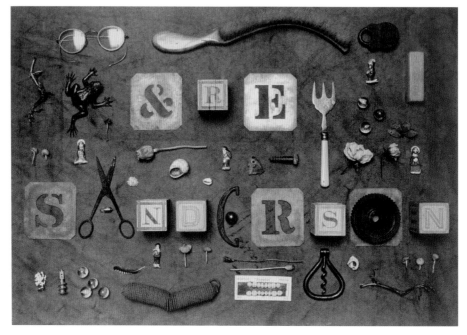

Cauliflower and colander.
Page 103.
Heads. *Above left.*
My name in still life. *Left.*
Roses in a jam jar. *Opposite.*

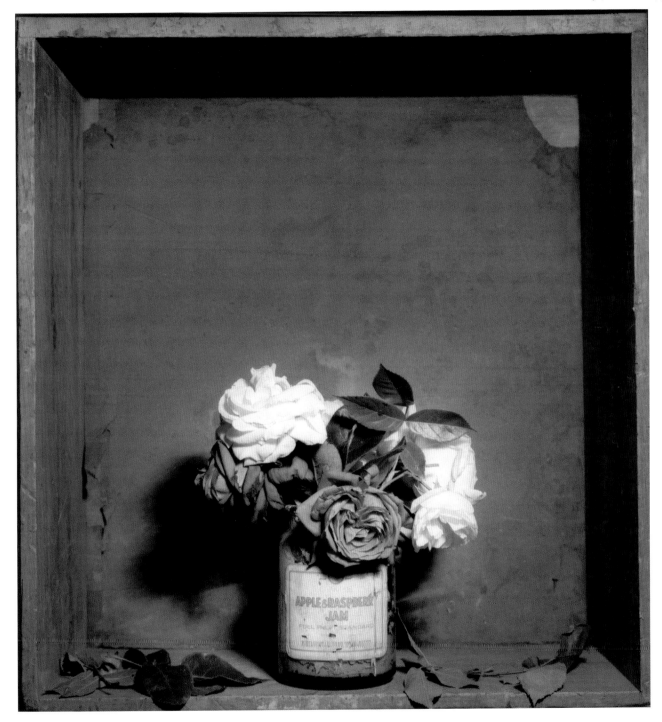

105

14 - A short walk

How about considering subjects outside?

Now that we have covered the subject of photographing at home fairly extensively, how about considering subjects outside?

How far from home is completely up to you, and that may be as near as your doorstep or much further afield. I don't intend to get into a long section on landscape photography here because that is a subject for a complete book in itself, but we can touch on it and suggest photographs of things which are, strictly speaking, landscape, but can still be photographed from your doorstep, such as clouds, or trees if there are any near to your home.

If you live in a built-up area, there may be photographic possibilities in the silhouettes of the roof and chimneys opposite, or distorted reflections of your own roof in the windows of other buildings. Try looking down at the ground to see if the road markings could be made into a picture. The patches of different kinds of tarmac left by roadworks can look abstract when photographed from above, and the seams between where hot tar has been poured may also look interesting. Road grates of different design and in different states of decay or wear make a subject in themselves and could be the subject of a complete series. If I can slip in a quote here, Gary Winogrand famously said: 'I photograph things to see how things look when they are photographed.' This sums it up very well: photography is a process of discovery, both of knowledge and of exciting visual experiences.

Heavily populated areas are ideal for many kinds of photographic series. Think of anything to be found near people and you will find many variations and ideas for shots. I can think of a few off the top of my head just now: shop displays, letterboxes, door handles, people, railings, hubcaps, rooftops, puddles and shadows. Any one of these subjects could be explored and pursued either as a series or just for a single image. Try a few of them out before deciding against them; they may reveal some unexpected quality once printed.

Graveyards are usually very photogenic places, especially in mist or fog. Parks also look great in the mist and are full of possibilities in good weather, too. There are always plenty of trees in parks which are a constant source of pictures, and these can be photographed in many different ways, in all types of weather and at any time of day or night.

Distant cloud. *Opposite.*
By breaking the rule to always focus on the foreground, I have made the cloud the point of interest and created a dream-like effect.

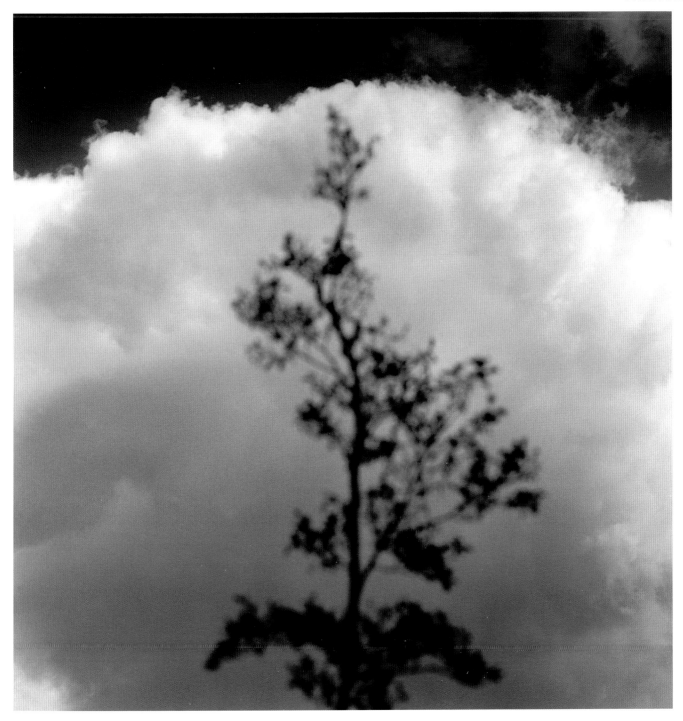

Demystifying photography

The quality of photography that you produce is dependent on the amount of time that you are willing to devote to it. So the obvious question is: are you shooting enough? A possible reason for not producing many good pictures is that you are probably not taking enough – the more you do it, the better you get. I don't mean pick up the camera once a month and run off a number of films at a sporting event or whatever. Shoot every day, think about pictures every day, use the camera every day. The ability to see pictures comes from exercising that part of your mind as much as possible; any period of abstinence causes you to become 'rusty'. It is definitely not like riding a bike, the ability does not stay with you unless you use it. One way to keep it functioning well is to look at the work of good and great photographers. Avoid looking at the work of poor photographers, as this will also influence your vision. Seek out high quality photography and think carefully about how it was done.

Many times there are big clues in the picture. For instance, ask yourself where the light is coming from, are there two or more sources of light? If so, then how has that been achieved, by the use of artificial light, or reflectors? Is there a hard edged shadow or a very soft one, is it midday sun or late/early in the day when the sun is lower? Can you estimate the focal length of the lens used? Is it a wide angle shot or standard? Perhaps a longer lens? Has it been shot on 35mm or a larger format? Look closely and see if there is plenty of depth of field throughout the photograph, indicating a small aperture. Perhaps the picture shows very little evidence of depth of field, indicating a wide aperture and probably a fast shutter speed. If there is subject movement in a shot displaying shallow focus, then this would suggest low light or a very slow film.

There are many more ways to extract the information from photographs, but to list them would get boring. You must work it out for yourself. This is a useful excersise which helps to demystify photography. Asking these questions puts you next to the photographer at the moment of exposure. The important thing to bear in mind is after the technical information has been extracted: it is essential that you ask yourself whether this picture would have worked if any of these details had been different. Would the picture have been poorer had a larger or smaller format been chosen? And so on.

Once the essential points have been established, you have a valuable reference point for creating strong images in a similar situation. This kind of detective work saves a lot of wasted film and can be a fascinating exercise which can be enjoyed whilst reading a magazine or watching a film.

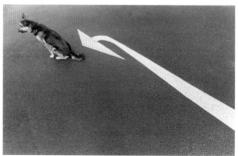

Windy day. *Far left.*
Stan. *Left.*
Metal garage door. *Opposite.*
Grass in the wind. Puddle. Double tree. Wasps' nest. *Page* 110.
Looking up through the leaves. *Page* 111.

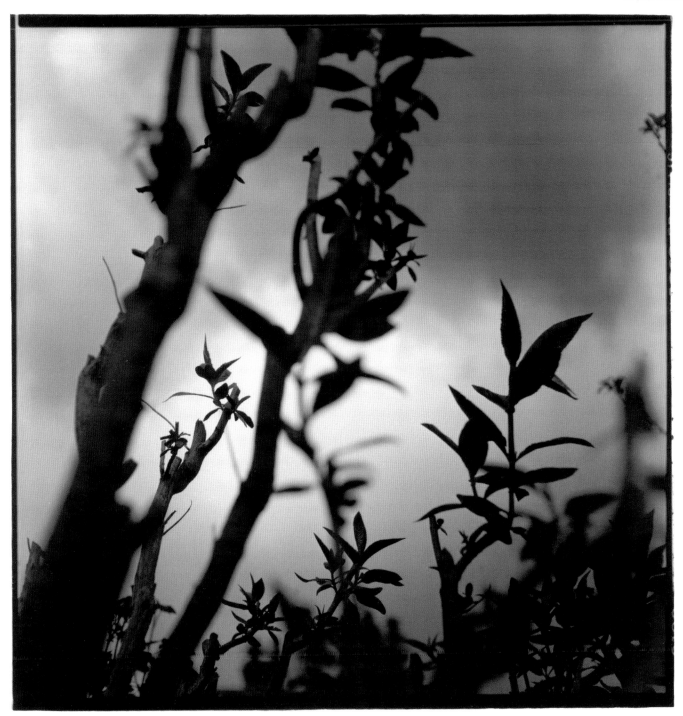

15 - Exercising your vision

Learning to see photographs everywhere is an ability that many people could easily acquire.

This section is about practising how you look at the world and how you perceive it.

Learning to see photographs everywhere is an ability that many people could easily acquire. It is often a simple matter of being aware that you have an awareness that you are not aware of! If you re-read what that says, it actually sums it up quite neatly: you may have an awareness that you often utilize but have never questioned. For instance, if I was to stand behind you and pull out one single hair from the back of your head, you would most likely feel a small irritation at that point, and reach round with a finger and scratch it.

Now ask yourself - how did you locate that very small area with your fingernail? Did you see in your mind's eye an image of the back of your head from my viewpoint? Or did you have a sense of the back of your head from the inside? I don't have an explanation for this, it has puzzled me for years, but I do have a great respect for the endless abilities of the human mind, and I believe that if you trust your own grey matter, it will reward you many fold. Obviously, the type of awareness that is most desirable for us as photographers is a visual one, and we need to learn to see as other great photographers have seen.

I believe that seeing is the most important aspect of being a photographer. I know that some believe that technical ability should come first, but a sharp, well printed image is not necessarily a strong one. Think about some of the great images in the history of photography that have not necessarily relied on sharpness: there have been many that were, and remain, extremely good pictures, such as those by Edward Stiechen, Robert Demachy, Baron Adolph de Meyer, Clarence H White and later workers such as Bill Brandt.

Pinhole photography is an ideal example of how strong images can be created with unsharp 'optics'. There are many modern exponents of the pinhole camera who find sharpness a secondary consideration, putting observation first.

I mentioned about thinking visually, and I should like to add another important point. Visual awareness – which you would think was essential for a photographer – will not produce a strong picture unless it is linked inside you with your feelings. It is not enough to simply notice something: you need an emotional response, too. This can be very subtle, in fact that is the crux of it, learning to recognize that very faint change in our feelings when we look at something. I think perhaps we all have it, but some of us are so desensitized that we don't recognize the signal – we can't feel it. This is the awareness that we need to develop, one that can recognize when our vision affects our feelings, such as the unusual perceptual shift which happens with peripheral vision.

Leaves in the paddling pool.
I *enjoy making images that take a little time to decipher. This is one of my favourites in the series. This kind of picture is purely down to visual awareness; technique has very little to do with it.*

Seeing with peripheral vision

Learning how to see is obviously the most important part of creative photography, as I have already mentioned. How this is done is not something that can be taught through the medium of the written word. Creative visual thought is a right brain function, whereas logical thought resides in the left in most people. Great pictures are not 'worked out' but felt. So the actual experience of seeing photographically is a function of the right brain, but describing it is a function of the left!

If you shoot instinctively, you are probably right brain dominant. You may notice that often an inspiration comes from the corner of the eye before it is properly looked at. This is because the central part of our vision is processed by the logical, left side of the brain, but the outer edges of vision are processed by the right side, which is where the creative unconscious is seated. A simple way to demonstrate this is to deliberately look at something with the outer edges of your vision. Try this:

Sit in a room in your house with your back quite close to one wall – the rest of the room, within your area of vision, must have a number of things to look at – this doesn't work in a completely empty room. Fix your vision on something opposite, roughly in the centre of your view. Now, without moving your eyes, become less aware of the point that you are fixed on, and more aware of things which are further away from that point. When you have your attention pretty much fixed on an area outside of the centre, try to get a feel for the whole of the field of vision – except for the centre. It will change the way you feel about what you are looking at. Keep looking until you experience some kind of shift in the way that the scene affects you, a change in your awareness of that which is before you. Practice this a number of times a day if you wish it to happen spontaneously. As we all know, practice makes perfect, and although 'perfect' peripheral vision probably doesn't exist, it nonetheless becomes much easier to do after practice. It only takes a few seconds and can be done anywhere.

When this technique has been practised, it will surprise you by happening spontaneously. This will give you a sudden shift in the way you percieve a place and you will have a kind of photographic recognition of the space.

Face in the fence post. *Left.*
Face in the bark. *Opposite.*
Faces appear all over the place, in clouds, stone and most commonly in wood.

Being visual

As a child I used to spend a lot of my school time looking out of the window instead of getting on with my work. It seemed perfectly natural to me, why didn't everybody else look at the clouds blowing by?

With the passing of time I've come to recognize being visual is a gift, although it has seemed like a curse at times. For instance, when I am introduced to someone for the first time, I am often distracted by the look of their hair or the interesting lines on their face, and then five minutes later, I can't remember what they are called. Or when I am trying to find my way across town to where I parked the car, and I can't remember where I parked it, or how to get back to it! I must have been too busy seeing pictures in the cracked pavement or the reflections in the shop windows.

As a parent I can now understand the need for children to pay attention and be aware, and I wonder how my parents coped with such a dozy son. I was extremely lucky, in that they did not put me under any pressure to conform. Perhaps that is also why I never felt the need to rebel as a teenager – there was nothing to rebel against! They allowed me to discover my own strengths, and one of these was my visual sense, which seems quite obvious now, but must have been a frustration at times. I certainly think it was for my teachers at school. During all of my time there, I was labelled as a day-dreamer.

I said that being visual could also be a curse. In my case, I spent so much time looking that I seldom paid attention to anything. As I grew up, the real world seemed a complete mystery to me; I didn't fit in, I always felt, and still do to a certain extent, like an outside observer. As I reached my later teenage years I began to discover things for myself, and consequently had a voracious appetite for information on a number of subjects, one of which was obviously photography. Other passions of mine have been music, wild funghi, hypnosis, psychology and NLP, and I have read extensively on these last three subjects.

The hypnosis was very useful, as it gave me increased abilities in the areas which had previously been lacking. I'm referring to confidence mainly, but also concentration and in my interaction with other people. It also had a beneficial effect on my photography. The great advantage with self hypnosis is that you can tell yourself that you are good at something and you believe it, so you produce better work. I used it in my early years as a photographic student and I am convinced that it made a difference.

Getting back to the subject of being visual, I believe that many, many people are visual, some to a great degree, some to a lesser extent, and that a lot of the world's 'lost souls' – those who find it difficult to live in the real world – could very well have the same 'problem' as me, but without the support and advantages that I have had. The world seems largely to be run by people who are driven by words and numbers, and they are totally insensitive to the needs of the visual members of society. They consider us to be stupid because we are not like they are. I consider that it is they who are missing something vital: how can a person survive without seeing and feeling the beauty that is all around?

Scene of death.
This was very much as I saw it, I only extended one leg shape a little to get the proportions right. You will have seen bubbles in the washing-up many times, but have you ever really looked? Stay aware and look out for pictures everywhere.

A *little exercise*

As a teacher of photography, I have known students who have had a very narrow view of what are acceptable subjects for pictures. When I have suggested topics, or shown my own work, questions such as 'can you photograph that?' or 'is that allowed?' have surfaced.

I believe that you can photograph virtually anything in the world and make a powerful image. By that I don't mean that all subjects should be photographed – some will always be socially unacceptable and taboo, and they should stay that way. I'm not trying to make a statement to annoy some readers, I am only trying to suggest to you that your horizons should be expanded and your eyes should be opened to the possibilities around you. For instance, what would you photograph if you knew that no subject was beyond your abilities, if anything was possible, where would you look for inspiration?

Look around you now: is there an object or ornament nearby? If so, just take a few moments to hold the thing in your hand and really look at it. Imagine it as a photograph – by somebody else if you find that easier, perhaps a photographer you admire or have seen published recently. How would it look? Could you mimic that? If none come immediately to mind, then create one in your imagination, a superb photographer. Your imaginary photographer could create something great from this object – you can see it in your mind's eye – now all you have to do is re-create what you just saw – copy it.

Does this way of approaching the subject make you see it differently? Try looking through your camera at it, notice how when you focus on the surface closest to you the background drops away out of focus, especially when you get close to it. Does this help to isolate the object and make it look more photogenic?

I think the problem for many who consider themselves poor photographers is that they think that it is enough to just point the camera vaguely in the direction of the subject and fire, the expectation being that the camera will magically arrange everything in the view and create a great shot.

I'm sure we all know people who claim to always crop people's heads off when taking a picture – how is this possible? They must have no awareness of what they are actually seeing through the viewfinder! Taking a little time to get everything right in the viewfinder before the shutter is fired will result in a higher proportion of good pictures. As you look through the camera, imagine that you are viewing a finished transparency if this helps.

I think in black and white when I look through a camera because that is what I have predominantly used for twenty-five years. On the rare occasions when I have put a colour film in, I see things differently and I suddenly become aware of the colours everywhere.

Pear and shadow.
*I took the pear out into the garden to see how it would look in the grass.
I put it down whilst I set up the camera and noticed the long shadow,
which then became more important than the pear.
Being flexible and open to other possibilities in this way means I have
more inspiration and more photographs.*

118

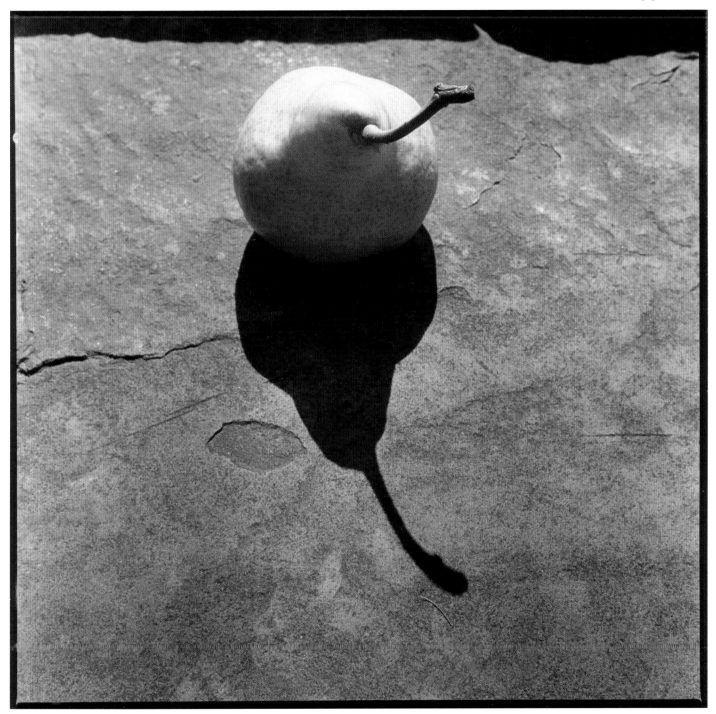

Composition

Composition is an odd thing. You can't learn how to do it from a book, but once you have learned it, you have to try to forget it.

Following 'rules' of composition will produce stale predictable pictures, but having no concept of composition will result in pictures which are worse. It is not so much that composition should be adhered to, more like 'consulted'. The shot may suggest a bending of the rules of composition, or an adherance to them, sometimes they may simply be abandoned. Knowing when is an ability that comes with thinking visually for a long time.

As Henri Cartier Bresson once said: 'I love principles, I hate rules.' If you can understand the principles behind composition, you can cope with any eventuality, but if you only have rules, then many times you will be struggling to understand when or why to use them. Compositionally, I could say that most strong photographs (press photos of disasters, wars and assassinations aside) are powerful because of viewpoint, composition and strong lighting (or clever printing, which can simulate strong lighting).

The main strength of a picture comes from the arrangement of the shapes and tones within a delineated area. Some prefer shooting on a square format, others prefer the 2:3 ratio of 35mm cameras. Whatever your preference, the frame is a box, and you fit things into it. What you choose to leave out of it is as important as what is shown, and the spaces between things in the box are perhaps even more important.

When photographing things and weighing up the compositional possibilities in your head, hold onto this quote from Max Weber who taught at the Clarence H White school of photography (1910): 'don't just photograph things, photograph the inbetweenness of things'.

This is a very important phrase. He is telling us that the spaces between things, the negative spaces, are as important, sometimes more important, than the subjects themselves. How much space you leave between things and around them is infinitely variable, and there are no rules that I can pass on to you. You must develop a feel for it, an instinct about when things are right in a picture. Looking at the way other photographers have made use of space will give you a greater understanding of its importance.

Other elements of composition such as scale, proportion, balance, tonality, etc. are important, but each element of composition is like a band of colour in a rainbow, each blending with the next and having no discernible hard edge. Each colour is beautiful, but you may choose to paint your house in a pale colour not represented on the rainbow, and your neighbours will choose some other colour. My analogy is that personal taste will dictate how composition should work for you, and so you should not let yourself be swayed by someone else's version of what is in the rulebook.

Pebbles.
A collection of pebbles arranged on a piece of stiff white paper on the windowsill. The edge of the paper is showing along the lower edge of the frame and alters the proportions whilst giving more contrast.

Can you manage with your equipment?

Do you believe that you are limited by the camera equipment you currently own?

Maybe you are thinking: 'If I move up to medium format/5x4"/10x8", I will produce better pictures.' Look around at what other people create, look through books, magazines, pick out all the pictures that really impress you, ask yourself whether this or that picture would only work using the equipment that the photographer describes or whether that shot could have been taken on other equipment. With many pictures what makes the difference is probably just the photographer taking more care over lens choice, using a tripod, accurate exposure reading, angle of view and lighting (and being in the right place at the right time). You can narrow this down to three important elements, assuming the camera is taking care of exposure: being in the right place, seeing and composition.

If you intend to take shots at home, then you are already in the right place and the right time is now.

How much equipment do you need to take great pictures? Well, this can be answered in two ways: hardly anything, and as much as you can get. I often find that a new (or recently acquired, shall we say), piece of equipment will inspire me to take new pictures. Changing formats always gives a different way of seeing, but at the same time, pictures can be made with one camera and one lens – or even without a lens in the case of pinhole photography. Should you feel that the quality you are currently getting is not as good as you aspire to, then moving up to medium format is perhaps worth considering (I must just say here that most users of 35mm do not achieve the maximum quality that these cameras are capable of, due to sloppy technique).

Some 35mm users are put off medium format photography because they believe that the larger cameras are harder to use. This is not so: the slower, more deliberate way of working that medium format requires is an advantage, not a handicap, as it forces you to think much more about each shot. Some resist moving up to medium format, believing that this will be the thin end of the wedge, that this will lead onto a habit which demands larger and more expensive satiation. There is some truth in this, as the excitement over the new results are projected forward – if moving up to medium format makes this much difference, then just think what could be done with 5x4", and then 10x8"! For most, medium format will be as far as you need to go. If you never print above 16x12" then just say 'no' to larger formats. 5x4" does have certain advantages, such as the various movements, but comparing it with an image from medium format on medium to small prints is not going to show much of a difference.

Although I have stated that great pictures can be created with the minimum of equipment, I am guilty of collecting cameras of all sizes and formats, the largest being a home made 20x16" camera constructed from a salvaged Agfa repromaster. Other formats I have include 10x8", 7x5", 5x4", and a wooden quarter plate Thornton Pickard which is especially lovely to use. (All of this stuff is so battered/obsolete/heavy/inconsistent or knackered that no one else would give it house room.) The smaller formats cover 35mm to 6x9cm and consist mainly of Pentax and Mamiya, with a few simple folding cameras in there too. I have cameras made from cigar boxes, catering size coffee tins, MDF, cardboard and plywood – in fact, most things which can be made light tight!

I still work with any form of lighting which is to hand, such as daylight, torches, angle poise lamps, small flashguns, etc. I believe that if the lighting is exciting, it needn't be replaced with bland softbox lighting, even though this would greatly simplify exposure calculation.

My way of working may seem rather luddite to some people, but I enjoy the challenge of working with difficult

equipment and lighting, it keeps my mind alert. I think auto focus and auto exposure are great advances in technology, but they make a photographer lazy. I also believe that the more effort expended, then the greater the satisfaction with a successful result. This is perhaps why digital photography has a short-lived excitement for me – it's great to play with, but it's not as good as the real thing!

Don't think that you need to have the range of equipment I have just described before you can begin to photograph. A simple 35mm is adequate for most situations. I often take pictures at home with very little equipment. I do have a studio, but I need to drive a few miles to get to it, so if I get the urge to take a shot of something in the kitchen or the garden for instance, then I have to work with what I have at hand. I don't keep studio lighting at home due to the limitations of space, so the options are: daylight, an anglepoise lamp, a torch, or a hand flash. I don't particularly like using flash, since you can't always be sure where the shadows are going to be. As Diane Arbus once said: 'when using flash, at the moment of exposure you are essentially blind'.

I prefer daylight, but the other options are very useful when I want some control over the direction of the lighting. They may seem like a difficult way to work, but I assure you that they are not. On occasions, if more than one light source is needed, you may have to ask someone to hold a torch, or light, in the position you require, whilst you operate the camera. If you are working alone, you have to be a little more resourceful, finding something to tape the torch to, or by setting the camera on self timer and holding the light yourself. As for backgrounds, most of the objects I have shot are small enough to be photographed on a sheet of paper less than A3 size, and this is easily put out of sight until required. Often I just use the table, the windowsill or the floorboards as a background, and this is fine for many of my subjects. Pieces of fabric in white and black, approximately four feet square, are also useful to have to hand, and I use these as plain backgrounds or to control reflections.

When it comes to choosing lenses, buy only what you really need. It is tempting to think that you need a full range of lenses, and you can easily convince yourself of that, but if you had all those lenses, then I'm pretty certain that after the novelty had worn off, quite a few of them would lie unused for many months, or even years (I've been there). A little thought can save a lot of money.

Investing in lenses is obviously going to be dependent on your budget, but the most expensive is not always the best. Many independent lens makers produce truly superb optics, and the quality of modern lenses is so good these days that it is virtually impossible to buy a 'turkey'. The optical quality is usually better than the film can resolve, so unless you buy a lens which has been dropped, or has mould inside, you are probably OK. Which focal length to get is a harder choice, getting a zoom lens that covers everything from rather wide, to long telephoto, is going to look like an advantage, but it will be a darker lens because of the greater number of lens elements within.

A darker, or 'slower', lens is a disadvantage when shooting in low light, such as indoors, and when a shallow focus is required to isolate a subject from its background. Slow lenses, which usually have a maximum aperture of between f3.5 and f5.6, can't give as shallow a focus as an f1.4 or f1.8 lens. Also, at their widest aperture they are often 'fluffy' and don't give a crisp enough effect.

Darker lenses are also harder to focus, both for us and for the autofocus mechanism. OK, you are probably thinking that I am not keen on zoom lenses, and you are mostly correct, even though I have a few. I am not totally against them though, they do have their uses, but not really for the type of photography which I am proposing in this book. Short zooms in the region of 28–80mm are useful for general pictures of children or outdoor shots, but for close ups, still life, kitchen pictures and many other styles mentioned here, a standard lens will be enough. An ability to focus close up is an advantage, but a supplementary lens screwed into the front will do the job very well.

You are probably asking: 'Is that it? Just a standard lens?' Well, not exactly. A superwide lens around the 18mm range is useful to have for interiors and wacky distortions of things, and a medium telephoto of around 120mm with an aperture wider than 2.8 is very good for portraits and for isolating flowers. The combination of those three lenses will give you endless possibilities.

The standard lens is the workhorse, though. I just looked through my selection of possible pictures for this book, and out of 210 images, 186 were taken on a standard lens, 23 on a telephoto and only 11 were with a wide angle. I think that says it all.

Visualization is something that a lot of new photographers have difficulty with. You can't look at a scene and imagine it on an 18mm lens if you have never used one; to get this knowledge you have to try out a complete range of lenses.

But carrying a full range of lenses would be a heavy option, and would actually make visualization harder. It is not possible to think in many different ways at once. The trick is to just go out with one at a time, don't take any other lenses or cameras. This forces you to see in one limiting way, to get you used to seeing which kind of shots would work on the chosen lens, and which ones would be pointless.

Take out the one camera and one lens, and shoot three films or until you have at least six decent shots. Then switch to something at the other extreme: if you began with a telephoto, then switch to a super wide. Do the same with this, shoot three films/get six good shots and then change that lens to a standard for the next three films/six shots. This way you really get to know what a lens can do and what it can't. It is a good discipline to restrict yourself in this way, because you have to think about the type of shots you are looking for. This method of learning works best with fixed focal length lenses rather than zooms, because with a zoom there is always the temptation to change the focal length to suit your position.

Let me expand on this a little:

When photographing with a zoom, the photographer tends to stay in one position and alters the focal length until the appropriate crop has been decided. Whereas with a fixed focal length, the framing of the image has to be achieved by moving around until everything fits properly in the viewfinder. Using the zoom method, the photographer misses all the other interesting angles and never gets to learn a valuable lesson of composition

about making things fit by choice of viewpoint. Using a zoom lens tends to make you lazy in your composition, and with telephoto zooms there is a tendency to get in too close. As the photographer Ernst Haas once said: 'The best zoom lens is your legs.'

That is about all I have to say. Bear in mind that to make pictures that other people will enjoy looking at, you must enjoy looking. Your enthusiasm will then be transmitted through your pictures. If you are driven to create (and this is not just confined to photography), then you must create. Don't let the opinions of others dictate your output.

Help! *This was a small rubber figure which attaches to the end of a pencil. I discovered it lying in this puddle, looking as though it was drowning.*
Great Britain shaped cloud. *It's not often that I walk to the shops carrying a camera, but luckily on this occasion I had one to capture the cloud (opposite) which was the shape of the British mainland.*

125

Thumbnails

These images are ones that didn't quite make it in to the main section of the book, but I felt they deserved a place. I present them here as an extra source of inspiration.

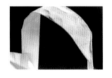 bag handle

 burned book

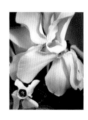 cyclamen

 bag of gravel

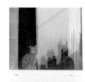 cat in window

 back garden

 bib

 cheesegrater

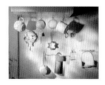 torchlit utensils

 branch and grass

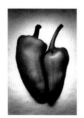 chillies

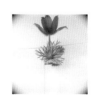 flower and card

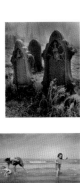 frosty graves

 Neil

 tea bags

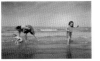 at Norfolk

 colander, eggs

 brush, plank, hoop

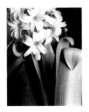 hyacinth 2

 Max

 tissue paper

 imaginary landscape

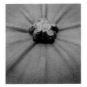 pumpkin top

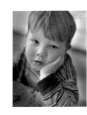 Will

 light through bottle

 sandpit

 Nellie and Stan

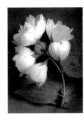 mock orange

 shop shadows

 reclining nude

Technical information

In many books and magazines you will see pictures with technical details such as: taken with a Tamron, Tokina, Vivitar or Sigma lens, 1/250 @ f8, orange filter, or some such detail. Have you ever questioned the use of this information? The actual lens make is irrelevant; virtually all lenses these days are excellent. As for the exposure details, the shutter speed used may be of some interest if it provides a particular effect, such as freezing motion, or at the opposite end produces an interesting blur, otherwise it is useless. The aperture may play an important role if maximum depth of field is required, or conversely, no depth of field at all, giving a very shallow area of focus. But a middle of the range aperture and shutter speed tells us nothing, neither is it of any use to anyone who wishes to visit the location of the shot to have a go themselves, because the lighting conditions would be totally different! The only useful things to note are: what focal length was chosen, how the exposure was arrived at, was a tripod necessary and whether a filter was used.

The picture itself will tell you all you need to know - instead of reading the 'technical' details under a picture, look closely at the picture and work out what the conditions were like for the photographer.

If you can develop an ability to 'work backwards' this way as you look at photographs, and by that I mean, imagine that you were stood next to the photographer, experiencing the same weather conditions, smelling the same smells, hearing the same sounds, but seeing it as you would there and then, through your eyes, not as a photograph, you can then understand how it was converted into a picture, irrespective of the technical details.

Photography is a thing that needs to be experienced, not just read about. The best way to accumulate information about these things is to go out and try it for yourself! Doing it will teach you far more than reading about it, so put this book down and go and get your camera. You can read it later.

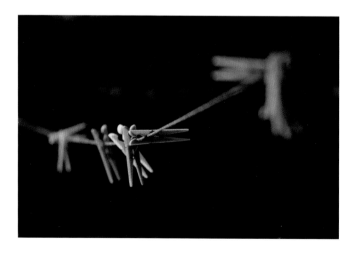